IMAGES
of America

HILLSIDE

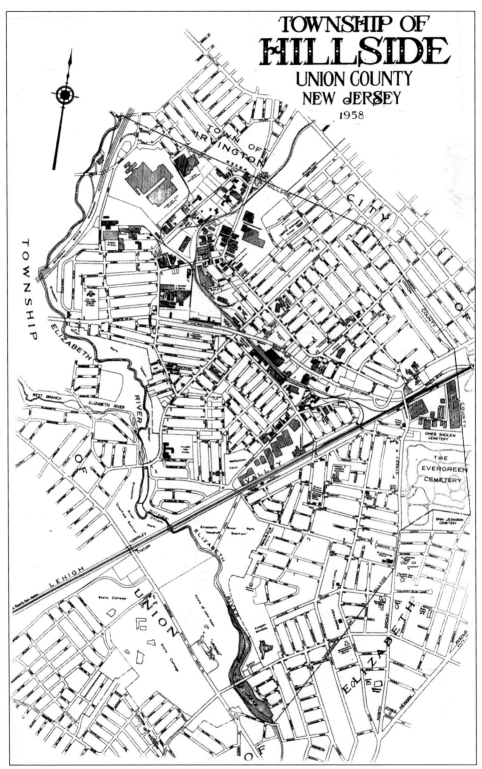

This map of Hillside dates from 1958.

IMAGES
of America

HILLSIDE

Jean-Rae Turner and Richard T. Koles

ARCADIA
PUBLISHING

Published by Arcadia Publishing
Charleston, South Carolina

Printed in the United States of America

Library of Congress Catalog Card Number: 2001089157

For all general information contact Arcadia Publishing at:
Telephone 843-853-2070
Fax 843-853-0044
E-mail sales@arcadiapublishing.com
For customer service and orders:
Toll-Free 1-888-313-2665

Visit us on the Internet at www.arcadiapublishing.com

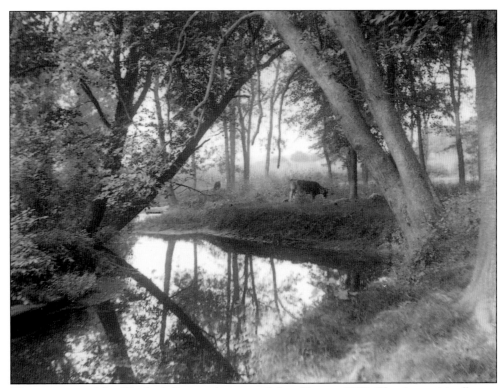

This is a view of the Elizabeth River taken near Salem Dam c. 1905. The dam originally was wood and built by George Jewell, the first miller, in the 18th century. The miller's house for many years was on a tiny island in the river. The mill race was along the Hillside side of the river. The mill burned c. 1912.

CONTENTS

ACKNOWLEDGMENTS

Many people have contributed to making this book. The Hillside Historical Association opened its files to us. Individual photographs were supplied by Arnold McClow, former president, and Alan Zimmerman, current president; Alice Anderson and Helen Witting, who have spent countless hours minding the business of HHA, as well as furnishing and serving as docents at the Woodruff House Museum and Eaton Store; Elaine Smith, who gave us the files of her husband, Edward Smith, a freelance photographer. Don L. Davidson, proprietor of New Jersey Newsphotos, gave us permission to use the photographs in his files. The New Jersey section of the Newark Public Library, headed by Charles F. Cummings, assisted us in finding photographs. Many individuals supplied photographs, including Lorraine Blake Brelowski, Stuart Cooper, Marian Courtney, Edna Doll, Marion J. Earl, Sally Wovsaniker, Shirley Frazer, Nancy Campbell, Donald Gillmore, Abe Haber, Edward L. Bowne, Lottie Smolenski, Eugene Krautblatt, Carl and Betty Laggren, Hillside Fire Department, Hillside Police Department, Rose Sena Stahnten, Frank and Gertrude Johnson, Elroy Mesz, Alois Stier, George Woodruff, Horace V. Tichenor, Dr. William R. Ward Sr., and many other people who loaned us photographs and told us about early Lyons Farms and Hillside. We are very grateful to you all.

—Jean-Rae Turner and Richard T. Koles

INTRODUCTION

The area known as Hillside originally was part of the Elizabethtown Grant. Most of it was known as Lyon's Farms and the rest as Woodruff's Farms because of the large number of people with those surnames. There were no boundaries to the two areas. Roughly, Lyons Farms (the apostrophe was dropped) extended from Hawthorne Avenue in present-day Newark to Salem Dam where Salem Road, Union Township, meets Liberty Avenue and Conant Street in today's Hillside. Woodruff's Farms included the present North Elizabeth Railroad Station on North Avenue and extended to the Elizabeth River, to Conant Street, and then to Coe Avenue, through a part of Evergreen Cemetery, and across present-day U.S. Highway 1 to the meadows in Elizabeth.

In November 1808, the section now known as Hillside was included in the new Township of Union because the farmers did not want to waste their time serving on the juries in Elizabethtown or traveling to Elizabethtown for other civic duties. Hillside continued to be an agrarian community until 1853, when 31 acres (later 115 acres) became Evergreen Cemetery. In 1890–1891, work began on the Lehigh Valley Railroad, cutting the future township in half. The trains carried produce to New York City and brought city people to "charming cottages" built close to the railroad in a new section called Saybrook. Clinton Township, a three-mile-wide wedge between Union and Newark, created in 1834, disintegrated. The last section, part of Lyons Farms between Hawthorne Avenue and Union Township, was annexed to Newark in 1902.

By 1905, city people were moving into the future Hillside and demanding city conveniences. Electric trolley cars carried people to Newark or Elizabeth for work. The train service made Hillside a suburban community for people working in New York City and Newark. Electricity was lighting houses along the Newark boundary. Oddly enough, the station at Saybrook was known as West Elizabeth and the one at North Broad Street (the Upper Road) as Elizabeth.

The farmers in the rest of Union Township wanted nothing to do with modern improvements. They were content to live as farmers had for 200 years. The movement for independence grew. Finally, on April 29, 1913, the people voted to form the Township of Hillside.

This is the story *Images of America: Hillside* will tell.

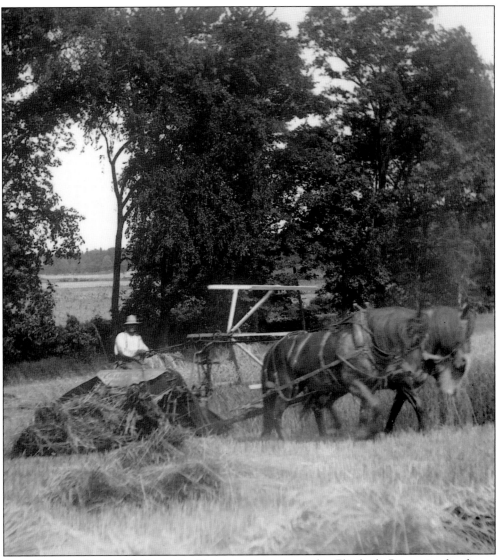

A worker cuts hay in 1905 on the Kean property, near the Elizabeth River, in the future Hillside. The Keans purchased the mills along the river for the Elizabethtown Water Company, formed on March 3, 1854. Drinking water was taken from the river. Four reservoirs were placed alongside the river. The largest was Ursino Lake, partially in the future Hillside.

One

THE BEGINNING

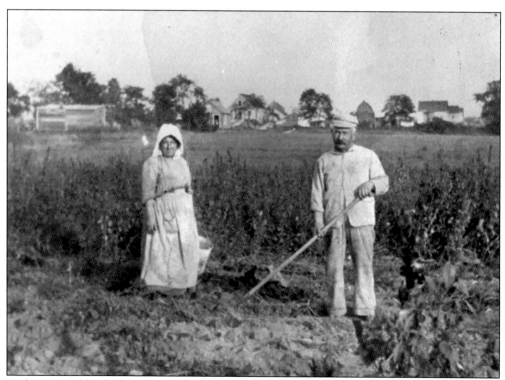

Katherine and Karl W. Engler work in their field off Liberty Avenue in 1901.

King Charles II of England gave his brother, then the Duke of York and later King James II of England, the land captured from the Dutch, including New York and New Jersey. James, who was in debt, gave the future New Jersey portion to Sir George Carteret and John Lord Berkeley as payment of that debt.

Peter Stuyvesant had control of New Amsterdam, as the Dutch called New York City before it was captured for the English in 1664 by Richard Nicolls, governor and captain. Stuyvesant was asked several times by New Englanders for permission to settle in the future New Jersey. He never said yes or no.

Lady Elizabeth Carteret was the wife and a cousin of Sir George Carteret. Their cousin Philip Carteret, captain and governor, brought the proprietors to East Jersey and named Elizabethtown for her. She never visited her namesake. Philip Carteret also named the area New Jersey for the Isle of Jersey, where the Carterets lived. It became East Jersey when the Carterets and John Lord Berkeley divided the property. The Carterets took East Jersey, and Berkeley took West Jersey.

Sir George Carteret, husband of Lady Elizabeth Carteret and cousin of Philip Carteret, was proprietor of New Jersey until his death. Philip's wife, Lady Elizabeth Smith Lawrence Carteret, a native of Long Island, sold her share as a proprietor and married Col. Richard Townley. The new proprietors were Quakers. In 1702, the colony was returned to the Crown.

11

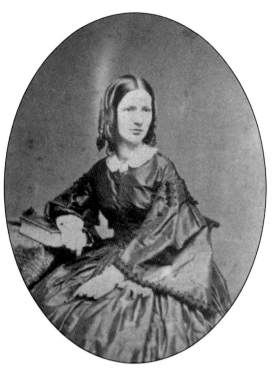

Members of the Hillside Historical Association found this painting in the Jacob Woodruff House when the dwelling was being restored. The woman is believed to be a member of the Woodruff family. The family resided in the house from the 1730s until the 1970s.

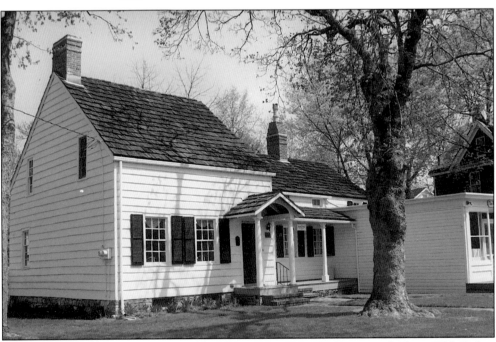

This is a view of the Woodruff House Museum as it is today. The house was built c. 1735. Before that time, a small portion of it probably had been used as a shelter against the weather and a place to store agricultural equipment by the first Woodruffs. Each early settler was given a town lot, meadowland, and woodland. This area would have been woodland. As the families grew, they turned the early shelters into homes for members of the family.

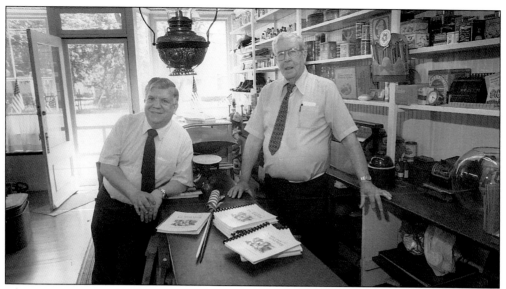

Alan Zimmerman, president of the Hillside Historical Society, and Arnold H. McClow, society founder in 1973 and past president, stand at the counter in the 1900 Eaton Store Museum. The store is the only one of its kind currently on display in Union County.

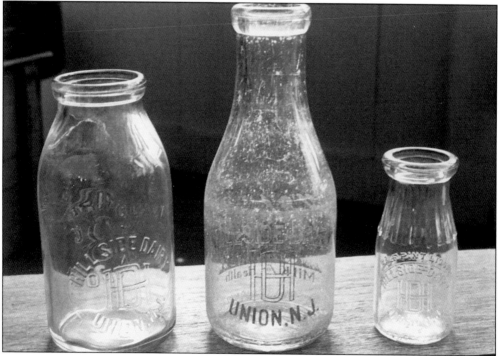

Milk bottles were being used for distribution when these bottles were made for the Hillside Dairy, before the separation from Union Township in 1913. Hillside had several herds of cows and several dairies until after its independence. Morris Zimmerman, who had a dairy on Bright Street, was proud when he sold the first cows to the future Tuscan Dairy, now in Union Township. One of the pastures for Tuscan was in the future Hillside and was used into the 1950s, when Tuscan began importing its milk from other dairies.

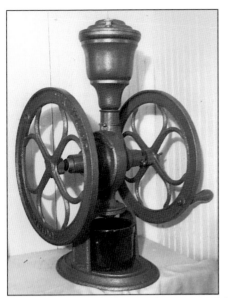

On the left, this coffee grinder is one of the objects on view in the Eaton Store Museum. All coffee had to be ground. Nobody had heard of powdered coffee in 1900. According to Jane Eaton Schorr, whose family operated the store from 1910 to 1927, the store was a gathering place for the neighbors and did a large lunch business for the men who worked on the farms and in the nurseries near the store. On the right, cornstarch and Karo were among the articles offered for sale in the Eaton Store. The store was used until about the 1930s, when it was leased to a candy maker. Later it was an art studio until it closed in 1940.

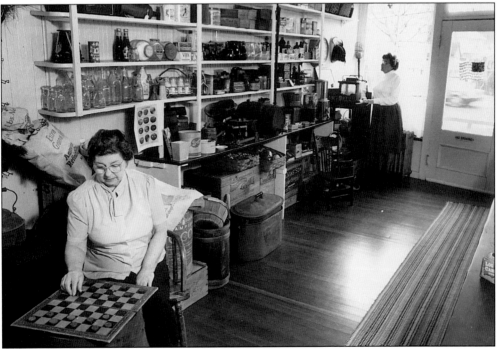

Alice Anderson studies a checkerboard once used by residents in the Eaton Store, while Helen Witting decides how to arrange another object.

This painting of a Woodruff woman also was found in the Woodruff house. She has not been identified. Since the camera had not yet been invented, people were painted or sketched.

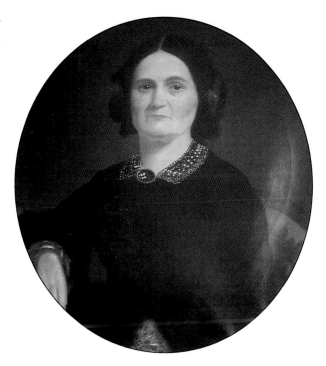

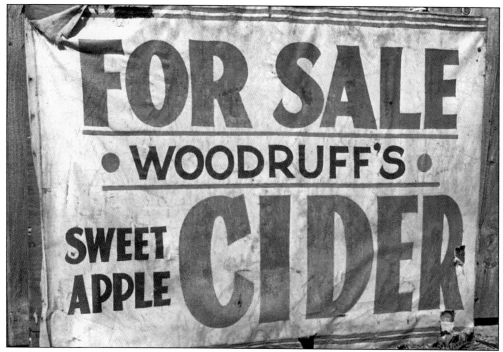

This sign was placed in front of the Eaton Store or the Woodruff Cider Mill, behind it, when cider was in season. Some of the older Hillsiders claim it was the best cider in town. The Hillside area was known for its apple orchards and cider mills. There were at least five mills.

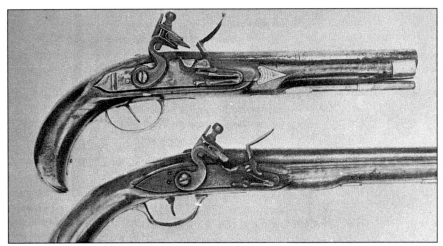

Every householder had either revolvers like these or shotguns during the Revolutionary War. The people lived in constant fear of night raids, sudden attacks, and battles with the British from 1775 to 1782. The British were camped on Staten Island only a few miles away. Cattle and other livestock were taken. Their houses were searched for Continental soldiers. Their valuables and farm produce were stolen. Their fences were torn down and the residents were terrified that their homes would be destroyed.

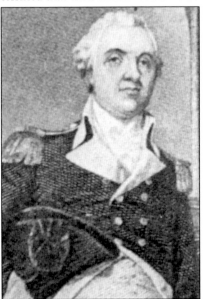 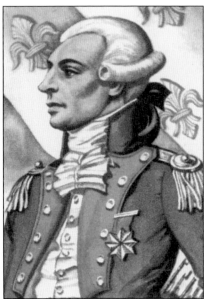

Gen. Henry Knox, left, commander of the Continental artillery, suggested a newspaper be founded to tell the Revolution story. It became the *New Jersey Journal*, later the *Elizabeth Daily Journal*. Knox also met with British officers in Elizabethtown to adjust accounts relative to prisoners of war and accompanied Gen. George Washington around New Jersey. The quiet of the hamlet was disturbed on September 24, 1824, by a visit from Gilbert Motier, Marquise de Lafayette, right, the boy general of the Revolutionary War. The visit was Lafayette's fourth and last to the new country as the "nation's guest." He was accompanied by Col. William Brown, an ancestor of Raymond Crane, whose house became the site of the first municipal building at 1284 North Broad Street in 1923. When the procession reached the Brown house, it stopped for welcoming ceremonies accompanied by the firing of cannons.

George Washington is said to have passed along the Upper Road through Lyons Farms four times: on June 25, 1775, en route to Cambridge to assume command of the Continental army; on November 28, 1776, during the famous retreat; on an unrecorded date, on his way to Morristown for one of his encampments; and, in 1797, en route to Elizabeth.

The drawing shows a wife saying good-bye to her husband as he responds to the alarm gun on First Mountain, alerting the members of the militia that the British are coming. Additional militiamen wait for him outside the house. Such alarms were frequent. A tar barrel on the mountain known as Beacon Hill was lighted at night to alert the residents.

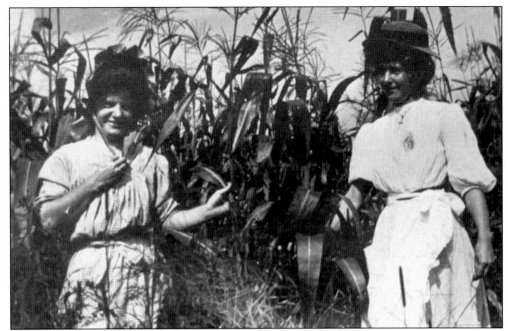

Gertrude High and Ernestine Engler Doll inspect the corn on the Engler farm off Liberty Avenue in 1912. The stalks are taller than they are. Asparagus also was a large crop on the farm. Liberty Avenue at that time ran only between the dam and Hillside Avenue; it is believed that the street was named during the Civil War.

Sylvester Looker first opened the Looker Store on the bend in the Upper Road toward Elizabeth. His son Horace Greeley Looker later took over the store. After the Lehigh Valley Railroad was built in 1890–1891, passengers for the trains from Lyons Farms made a habit of stopping at the store for their newspapers and mail, and to catch up with the hamlet's gossip before boarding the train. The store was removed in 1928, when the bridge was placed over the railroad.

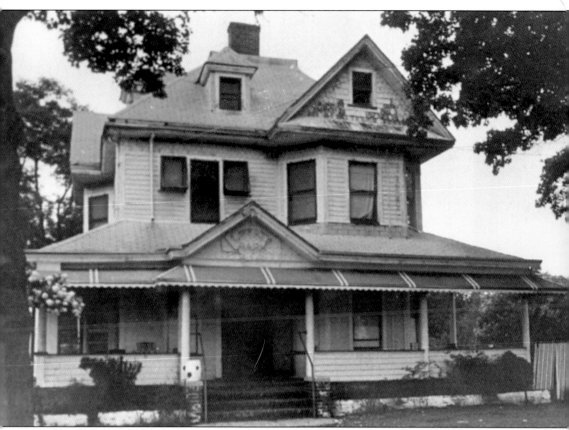

This Victorian house backed up to the Elizabeth River. For many years, it was a tavern known as the Liberty Inn or Kate's Place. The Hillside Shopping Center occupies much of the area now. The Paddy Watkins Home, an orphanage, was in a house nearby. Later, it was occupied by Samuel McMichael and then by Mr. and Mrs. John Dill, before it became an office building.

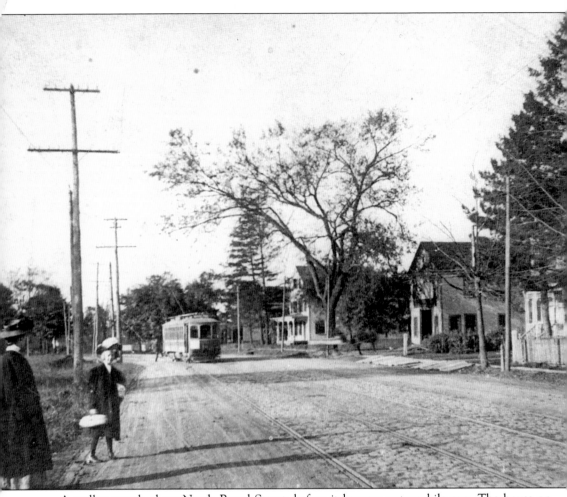

A trolley travels along North Broad Street, before it became automobile row. The house on the near right is that of Abram P. Morris, who was considered the "father of Hillside." Next to it is the home of William "Buffalo Bill" Williamson, whose major business came from shoeing horses at the racetrack in nearby Weequahic Park. The third house from the right was the Tillou house, where there was a cider mill. The final building was the law office of S.M. Cooley c. 1918.

Two

THE RIVER

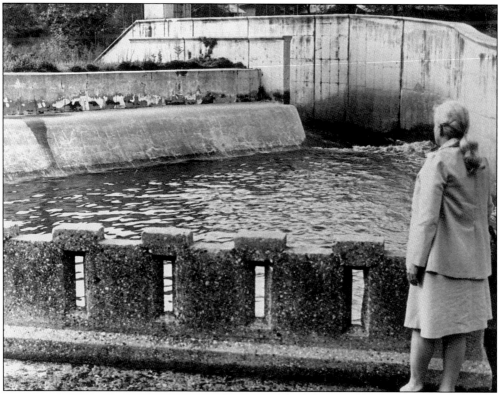

This dam at Trotter's Lane on the Elizabeth, Hillside, and Union border was removed when the reservoir known as Ursino Lake was drained. Two streams of the river now run through the area from North Avenue to Trotter's Lane where they join and become a single stream. The area once Ursino Lake now serves as a flood retention basin. The lake was named by the Keans for the estate of Count Julian Ursyn Niemcewicz in Poland, stepfather of Peter Kean. The count had tutored Peter and then married the boy's mother, Susan Livingston Kean, a niece of New Jersey's first governor, William Livingston.

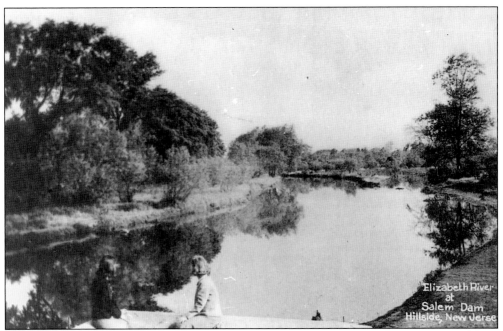

Helen Witting, right, sits on the bridge at Salem Dam in Hillside in 1935. This section of the river was used by the Saybrook Canoe Club in 1900. It has been an excellent site to catch fish. Today it is a favorite spot for Canada geese.

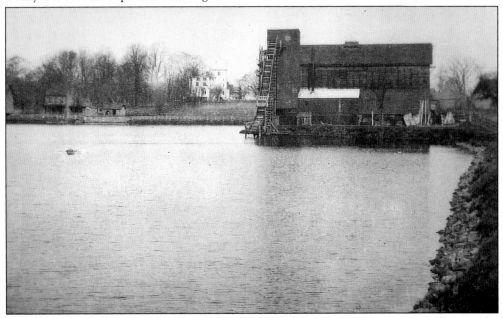

There were two icehouses on Ursino Lake before 1929. The white building in the background is Liberty Hall, the mansion built by William Livingston in 1772. The British, who were seeking to arrest Livingston after he became New Jersey's first governor, raided it several times during the Revolutionary War. It was owned and occupied by members of the Kean family from 1811 until the family formed the Liberty Hall Foundation in 1997 to preserve the estate as a museum.

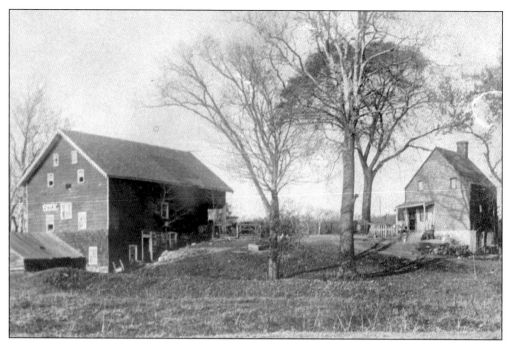

This house and barn stood near Salem Dam in Hillside in 1905.

This is the Joseph Meeker House, built after the Revolutionary War to replace the earlier miller's house. The Hillside Historical Society has placed a sign in front of it identifying it as "Grist Mill."

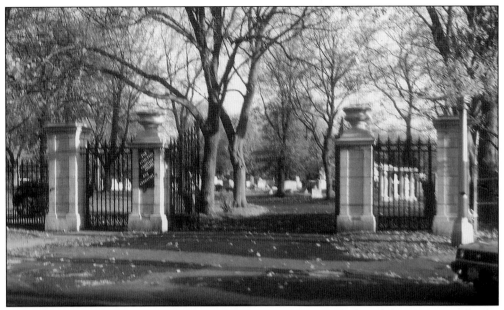

This is the main entrance to the Evergreen Cemetery on North Broad Street, originally the Upper Road. The Lower Road travels along the Elizabeth side of the cemetery. It becomes first Dayton Street and then Meeker Avenue and joins the Upper Road (Elizabeth Avenue) in today's Newark. The two roads travel around the swampy area, which became Weequahic Park in Newark.

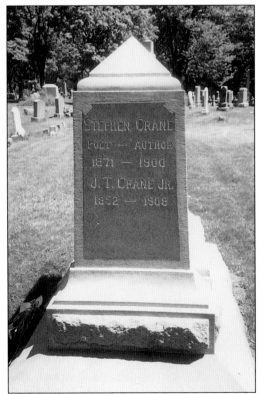

The Crane family tombstone in Evergreen Cemetery is the burial site of author Stephen Crane, who died when he was only 29 years old. He began his literary career working for his brother, Jonathan Townley Crane Jr., known as Townley in Asbury Park, where he operated a news service. Later, Stephen Crane wrote *Maggie, Girl of the Streets*, a novel about a young prostitute, and *The Red Badge of Courage*, in which he described the horrors of war. Both were controversial, and both were very successful.

Rufus King, whose home was on the site of the future Pingry School on North Avenue, was awarded the Congressional Medal of Honor for saving the Army of the Potomac in the Civil War in 1862. A first lieutenant in the 4th U.S. Artillery, King took command after his superior officers were killed during an assault by the Confederate forces and held his post as the Union army retreated from Richmond to Harrison Landing on the James River in Virginia.

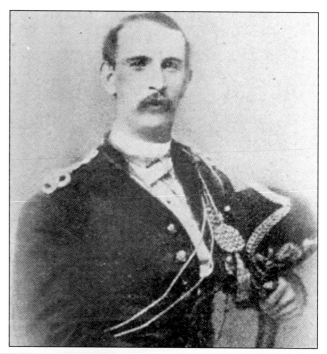

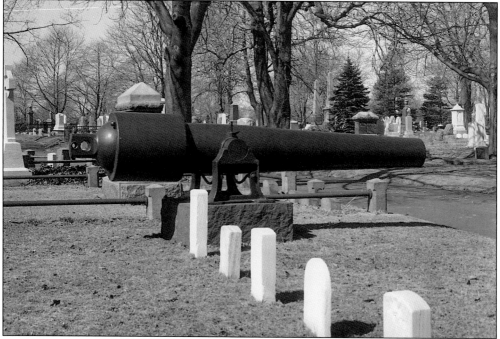

This Spanish-American War cannon is one of two that guard the soldiers' plot in the Evergreen Cemetery. The U.S. government issued the monuments. From 1940 until the early 1960s, the annual Memorial Day parades began at the Hillside High School at Salem Dam and traveled along Liberty Avenue to Hillside Avenue, to North Broad Street, and then to the cemetery. Now, the annual parades are scheduled in October and go only from the high school along Liberty Avenue to Memorial Drive near the municipal building.

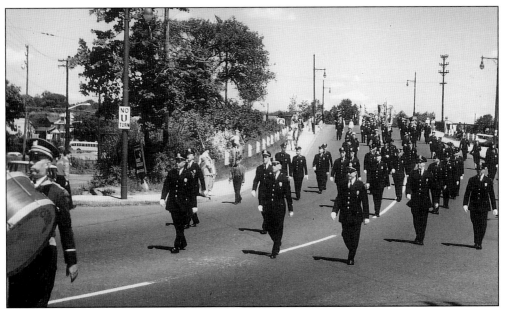

Among the marchers in the Memorial Day parade c. 1960 are members of the Hillside Police Department, crossing guards, and auxiliary police. They are marching on the North Broad Street Bridge over the Lehigh Valley Railroad and Route 22.

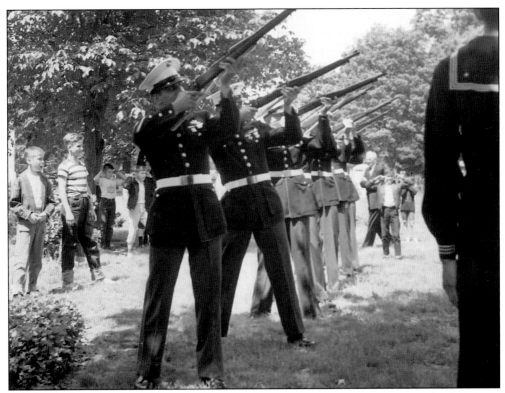

Members of the Marine Corps League fire a volley of shots during ceremonies at the Evergreen Cemetery c. 1960.

26

John Starr March of Newark was one of the five mail carriers on the RMS *Titanic*, when it struck an iceberg on April 14, 1912, on its maiden voyage. His body was the 225th to be pulled out of the Atlantic Ocean. The monument is the same as those put on the graves of unclaimed bodies in cemeteries in Halifax, Nova Scotia, Canada. The U.S. Postal Service and the *Titanic* Memorial Association placed the monument on the grave a few years ago.

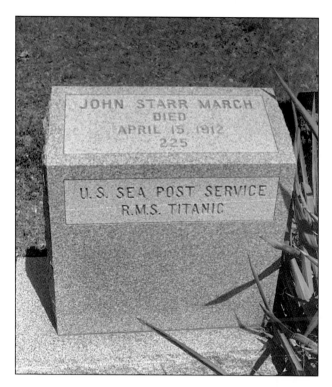

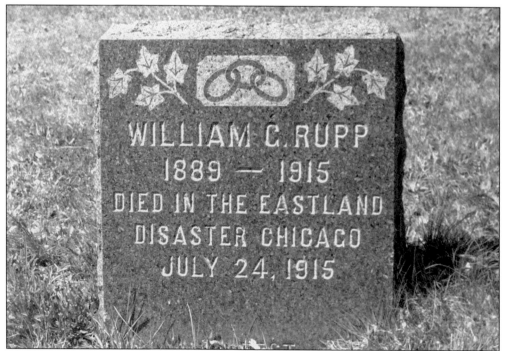

Oddly enough, William C. Rupp was drowned on the excursion boat *Eastland* in Chicago when 2,000 persons rushed to the side of the boat because of some sort of a disturbance. The ship overturned. His grave is near that of the *Titanic* victim.

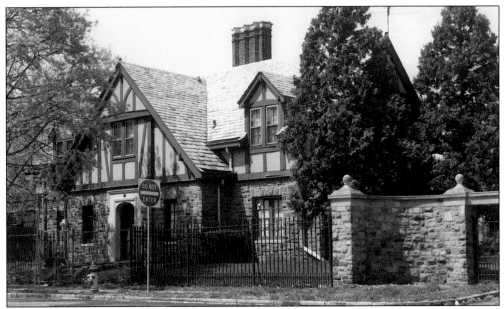

The chapel of the Evergreen Cemetery near the Dayton Street entrance was built in 1932. Geofrey Poggi, an Elizabeth architect, designed it. It is named for Rev. Dr. David King, rector of St. John's Episcopal Church, Elizabeth.

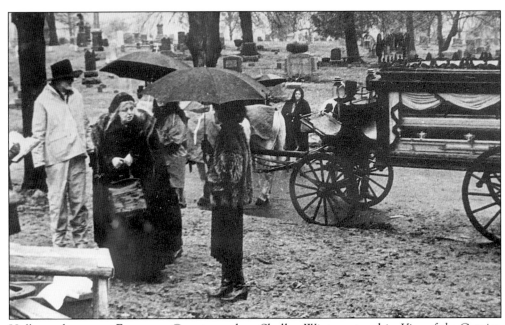

Hollywood came to Evergreen Cemetery when Shelley Winters stared in *King of the Gypsies*. Some of the scenes were shot in the cemetery. After the Civil War, there were three gypsy camps in the area: opposite the Lyons Farms School in Weequahic Park area, on an island near the Elizabeth-Newark city line, and in Vauxhall—part of Union Township.

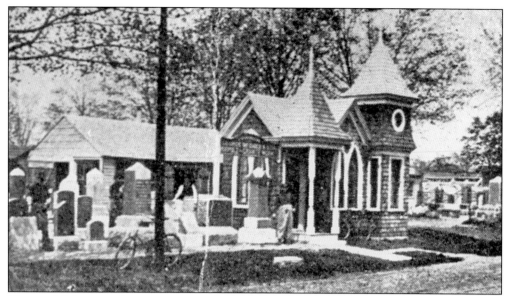

The establishment of a cemetery on the Upper Road in 1853 caused several businesses to move into the area. This is a view of the George G. McGhee Monument Works, built in 1871 to resemble a Gothic Revival church. Although the area technically was in Union Township, McGhee, two other monument companies, and adjacent florists all used Elizabeth as their address.

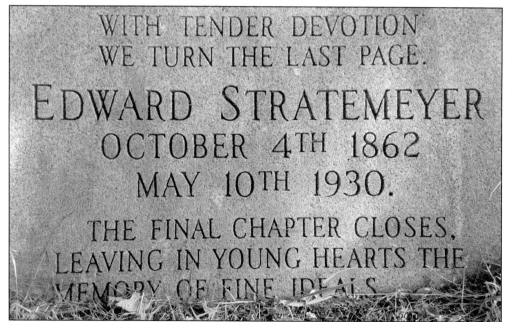

WITH TENDER DEVOTION
WE TURN THE LAST PAGE.
EDWARD STRATEMEYER
OCTOBER 4TH 1862
MAY 10TH 1930.
THE FINAL CHAPTER CLOSES,
LEAVING IN YOUNG HEARTS THE
MEMORY OF FINE IDEALS.

Edward Stratemeyer, who developed many popular series books, was buried in the cemetery in 1930. Among the best known of his series were Nancy Drew, Tom Swift, the Hardy Boys, and the Bobbsey Twins. He developed the cast of characters and the plot line, and had young writers write the books. One of the writers was Donald Barr Chidsey, who became author of numerous nonfiction young-adult history books. Chidsey also is buried in the cemetery.

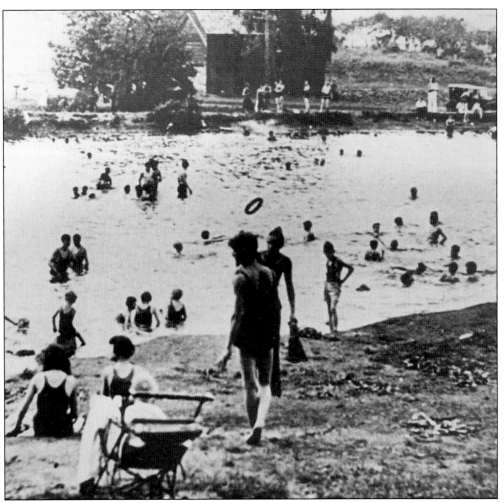

Bathers enjoy the Elizabeth River on a hot day in 1932, the year the Keans closed the river to swimmers because of pollution. The exact location on the river is unknown, but it probably was at Salem Dam where the earth rises from the water. Another favorite bathing place was the Dravis Pool, on Westfield Avenue.

Three

READING AND WRITING

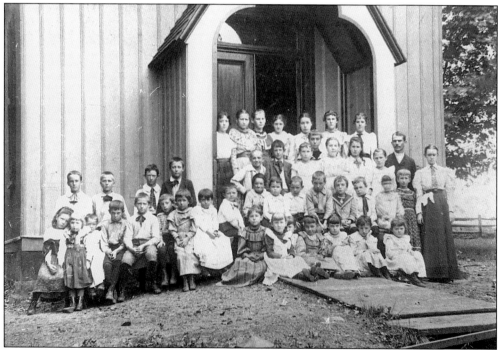

Salem School students gather in front of the building for their photograph c. 1885. The school, located just across the river on the left of Salem Road, was built to teach children on both sides of the river. After the Township of Hillside was formed, the school closed and it became an one-family house.

This small building was the first Saybrook School, on Virginia Street. It became a one-family house when the eight-room schoolhouse was constructed nearby in 1913. That building now houses the administration offices for the schools.

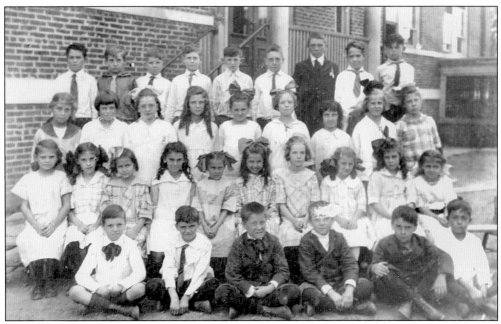

This is a class at Saybrook School in 1917, the year that Central Grammar School was built on Coe Avenue to relieve the overcrowding. By 1923, Central School was turned into the high school, Saybrook School annex and Hurden-Looker School were built, and plans were being studied to enlarge Hillside Avenue School.

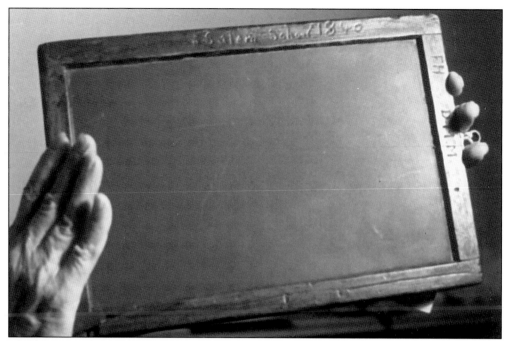

Children attending Salem School in 1840 used this slate. Slates were used for lessons before blackboards were available in classrooms. They also saved using paper for lessons. The slate is on exhibit at the Eaton Store.

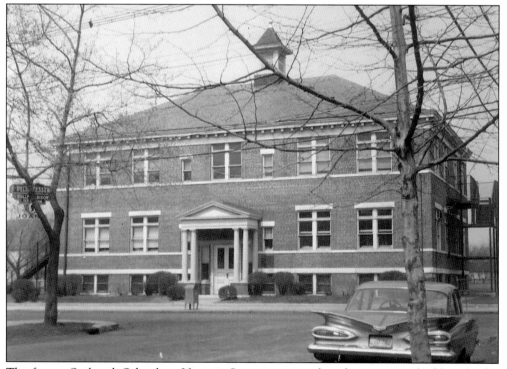

The former Saybrook School on Virginia Street serves as the administration building for the Hillside Schools.

These two young men lost their lives in World War I. Horace Russell Looker, left, was injured while fighting in France on September 17, 1918, when a shell exploded near him. He died shortly afterward. Edward Hurden, right, died of influenza in an army camp on September 12, 1918. Both were buried in France. The American Legion Post 50, a park at Mertz Avenue and Clark Street, the 1922 Hurden-Looker School, and two streets were named for these men. Memorial Drive, next to the municipal building, is named for the 78 Hillside residents who died in service during World War II.

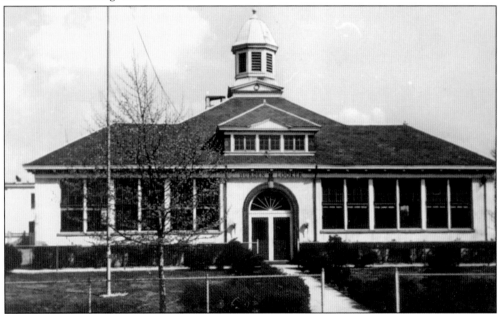

Hurden-Looker School opened in 1922. It has since been enlarged with two additions, plus the Harlow H. Curtis Sr. multipurpose room. The school is considered to be in the center of the community. The school was used for kindergarten through eighth grade or kindergarten through sixth grade until the township was charged with de facto segregation. Since 1988, the school has been used for kindergarten through fourth grade. In September 2001, the school was changed to third through sixth grades.

34

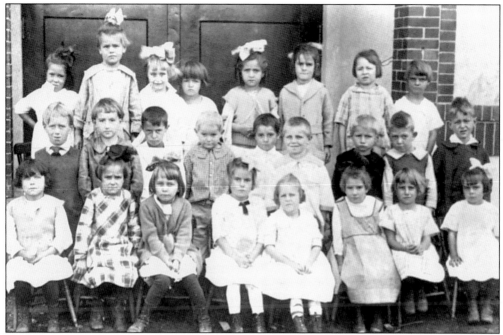

These children were in the first kindergarten class to enter Hurden-Looker School, in 1922.

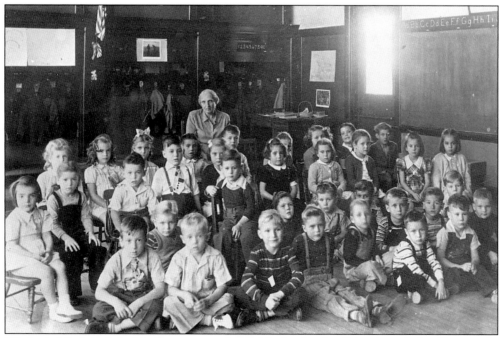

Elizabeth Mittledorf, the kindergarten teacher at Hurden-Looker School, sits behind her pupils, where she can keep an eye on them while they pose for this class photograph in 1947.

Pei Chen Owyady, a Chinese woman who lived in Hillside in 1947, visited the fourth grade class of Rose Sena Stahnten to tell the children about Chinese achievements. Rose Sena Stahnten later became principal of Calvin Coolidge and George Washington Schools and the first woman superintendent of schools.

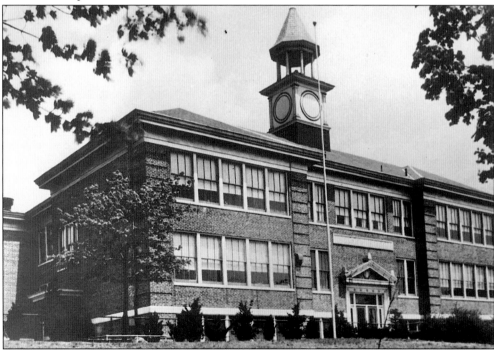

Hillside Avenue School, now Walter O. Krumbiegel School, still had its bell tower when this photograph was taken. The front part of the building was erected in 1913 to replace the old 1867 two-room Hillside School, at Lyons Farms, called the Little Red Schoolhouse. It stood at the corner of Hillside and Maple Avenues. When Dr. Walter O. Krumbiegel, the assistant superintendent of schools, retired, the school was named for him. Since 1988, it has housed the seventh and eighth grades.

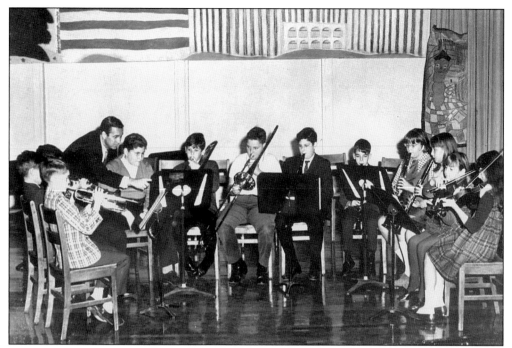

Seymour Stein, music teacher at Hillside Avenue School, suggests how a bar of music should be played to a youngster during a rehearsal at the school in 1964. The stage is decorated for the observance of President's Week in February.

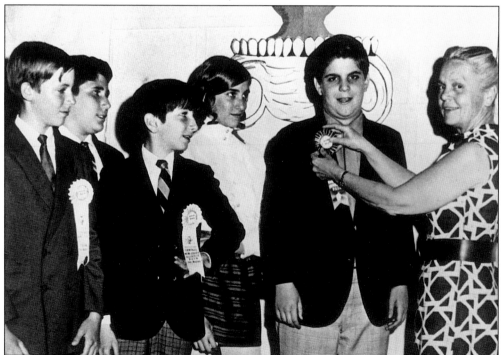

Edna Doll, principal of Hillside Avenue School, presents awards for outstanding scholarship to five students.

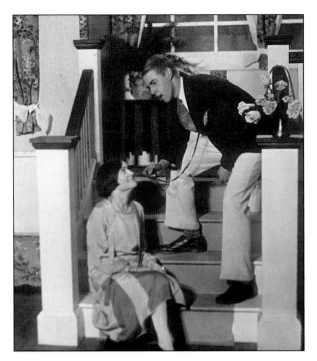

From the school's first year in 1923 until World War II, one of the highlights of senior year at Hillside High was the senior play. Esther Middleton and Allen W. Roberts appear in a scene of *Peg O' My Heart* in 1925. Roberts later became superintendent of schools in New Providence. The plays usually were presented in the Hillside Avenue School auditorium, which was used for many community activities.

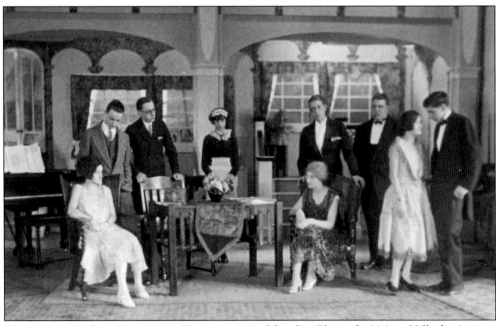

This is a scene from *Peg O' My Heart*, presented by the Class of 1926 at Hillside Avenue School. The cast includes, from left to right, Jacqueline Sherman, Alfred Dowd, Milton Hock, Catherine Tressler, Josephine Smith, Allen W. Roberts, J. Franklin Reinhard, Esther Middleton, and David MacNeill.

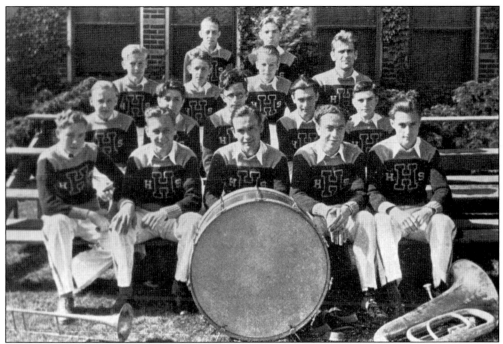

Sixteen youths played in the first band at Hillside High School in 1933. Later, when a drum major was added, a youth who could fit the uniform had to be selected.

Only 16 teachers were needed to teach the classes at Hillside High School in 1924–1925. Among those seated are Arthur G. Woodfield, superintendent of schools, center; Annamae Schmidt Rudolph, third from the left; and Wilbur Cox, far right. Among those standing are Samuel Dubow, far left; R. Dorothea Jones, wearing glasses, center; and Irwin P. Sowers, far right.

Charles B. Atwater and his wife sit in the yard of their home on Masters Square. He was headmaster of Pingry School in 1970. The school built the houses on the square for the faculty. They have since been sold.

The Pingry School was on North Avenue from 1953 to 1978, when it moved to Bernards Township. After a futile attempt by the Hillside schools to purchase the site, the North Avenue building and grounds became Kean University East.

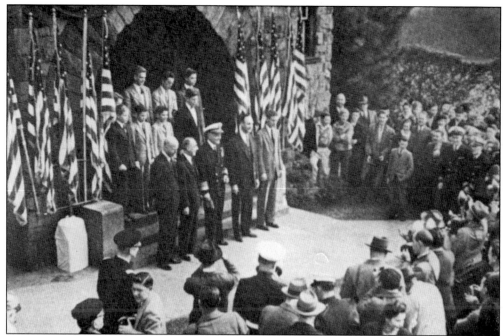

Adm. William Halsey, a native of Elizabeth, is a graduate of Pingry School. After World War II, he returned to the school c. 1946 for its Admiral Halsey Day. He is in uniform in the center of the row of five men.

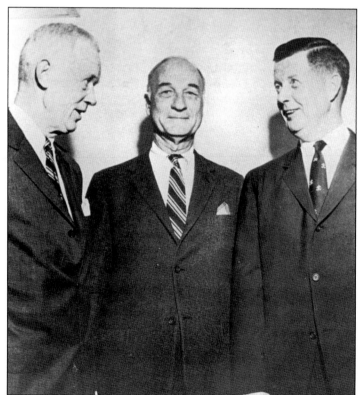

Rev. Dr. John F. Pingry started Pingry School in 1861. It moved into the Hillside building in 1953. Here, Charles B. Atwater, left, headmaster in February 1970, talks with E. Lawrence Springer, center, who served as headmaster from 1936 to 1961, and H. Westcott Cunningham, headmaster-elect in 1970.

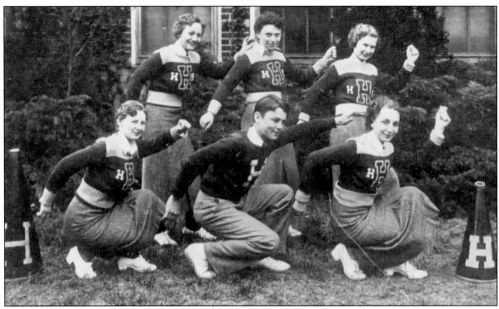

Hillside High School cheerleaders show their form in a practice session in the early 1930s.

The Class of 1925 was one of the first classes to graduate from Hillside High School. Before 1923, high school students were sent to Elizabeth. Many children at that time left school after eighth grade. The Great Depression caused more students to continue their educations into high school because of lack of jobs. The GI Bill, adopted after World War II, gave those who served in the armed forces an opportunity to go to college.

Helen P. Kirkpatrick, a school board member from 1946 to 1953, became the first female president of the board in 1952. Her husband, Robert C. Kirkpatrick, was mayor at the time. She became school district clerk in 1956 and served until 1967.

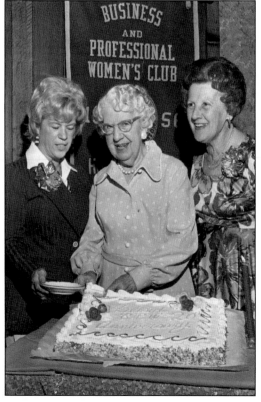

Jean A. White, usually known as Mrs. Emmet T. White, cuts an anniversary cake for the Hillside Business and Professional Women Inc. at College Inn. She organized the group in 1956. She also was an organizer of the Women's Club of Hillside, the PTAs at Saybrook, A.P. Morris, and the high school. She was one of the first women to serve on the Hillside Board of Education, from 1941 to 1945, when she resigned to become the school district clerk, a post she held until 1956. With her are Marie Oakie, left, and Marguerite Lynch.

43

Toddler Virginia Cox was selected as the mascot of the Class of 1929.

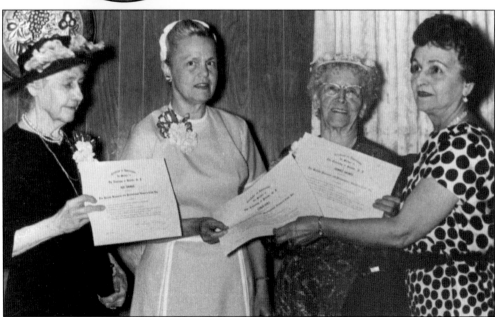

The Hillside Business and Professional Women's Club honored the First Ladies of Hillside on the township's anniversary in 1963. Helen P. Kirkpatrick, right, presents certificates to three women. They are, from left to right, Sue E. Savage, the first principal of Hillside Avenue School, from 1919 to 1946; Edna Doll, first woman coordinator of elementary curriculum when she became principal of Hillside Avenue in 1963, serving until 1971; and Jennie Haines, first principal of Hurden-Looker School, from 1922 to 1927, and of Calvin Coolidge School, from 1927 to 1939, when she returned to Hurden-Looker and served until her retirement in 1946.

The basketball team at St. Catherine's School is ready for a game.

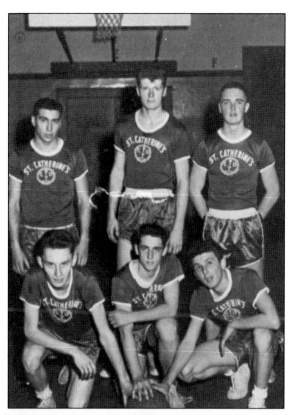

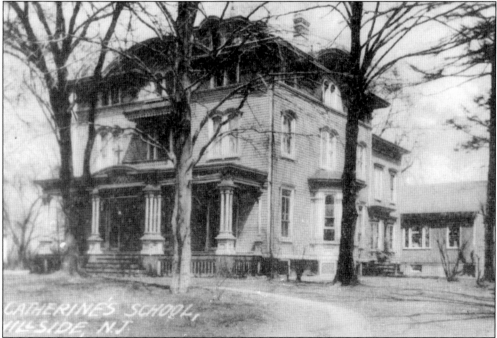

This house was used as St. Catherine's School until the early 1950s, when the present school was erected. Another dwelling close by was used as the nunnery.

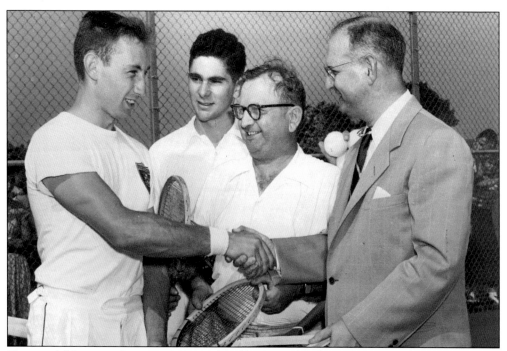

Two youthful tennis players are congratulated by Samuel Dubow, director of physical education in the Hillside Schools, and Henry Goldhor, a member of the board of education, at the opening of the first tennis courts behind the high school. Youths strung nets across dead-end streets for tennis before these courts were opened in 1951.

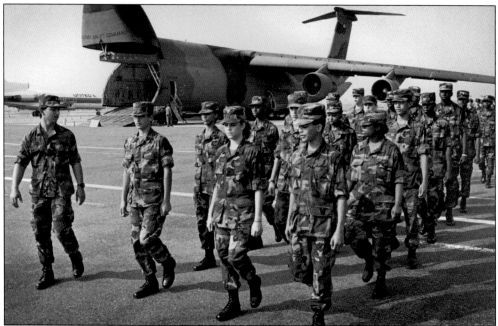

The Hillside High School ROTC marches during a demonstration at Newark International Airport during its observation of the airport's 60th anniversary. The ROTC was formed in 1980.

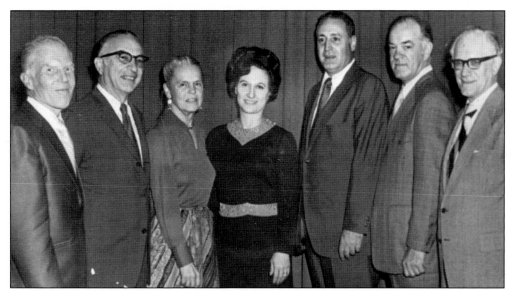

Edna Doll, third from left, is honored by her colleagues on her retirement as principal of the Hillside Avenue School in 1972. With her, from left to right, are David Harris, principal of Abram P. Morris-Saybrook School; John J. Lopresti Jr., principal of Hurden-Looker School; Rose Sena Stahnten, principal of Calvin Coolidge and George Washington Schools; Dr. Anthony A. Avella, superintendent of schools; John Kulikowski, principal of Hillside High School; and Dr. Walter O. Krumbiegel, assistant superintendent of schools.

The Class of 1926 celebrated its 50th reunion on October 10, 1976, at the Tower Steak House in Mountainside. Among those who attended were Allen W. Roberts, the former superintendent of schools in New Providence; Mrs. Frances Cormack; Mrs. Jacqueline Sherman Spitz, a former teacher in the Hillside schools; and J. Franklin Reinhard, a representative of insurance companies.

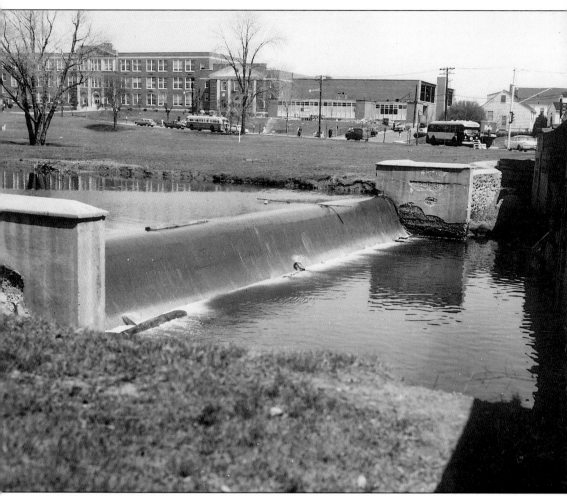

Hillside High School opened in 1940, across the street from the Salem Dam. The school was built on the former nursery of Hiram T. Jones. The school replaced Central Avenue Grammar School, which was used as the high school from 1923 until 1940. That school became the Abram P. Morris School, named for Hillside's founder. It served as the junior high school. In September 2001, it contained the early childhood, preschool kindergarten, and kindergarten through second grade classes.

Four

Earning a Living

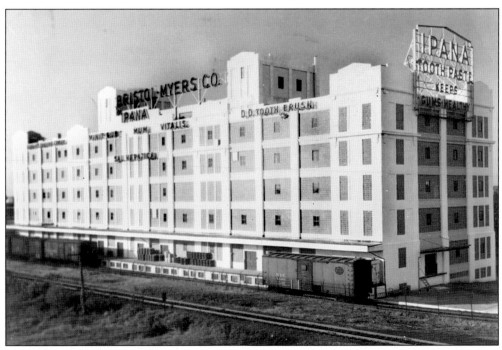

The Bristol-Myers Company moved from Brooklyn to this building on Long Avenue and Liberty Avenue in 1919, becoming the first major industry to settle in Hillside. It manufactured more than 4,000 health and beauty items. In 1965, it erected a research and development building on Liberty Avenue. The company became Bristol-Myers Squibb in 1989 and moved to Princeton. The research facilities continue to operate in Hillside.

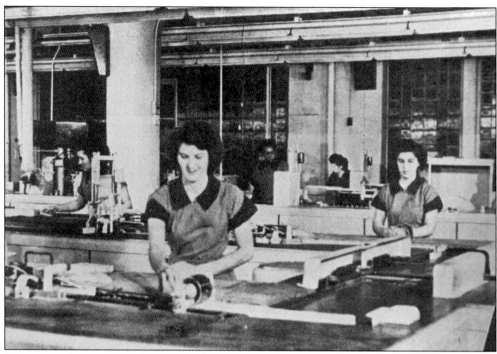

Women work on an assembly line at the Bristol-Myers Company in Hillside *c*. 1950.

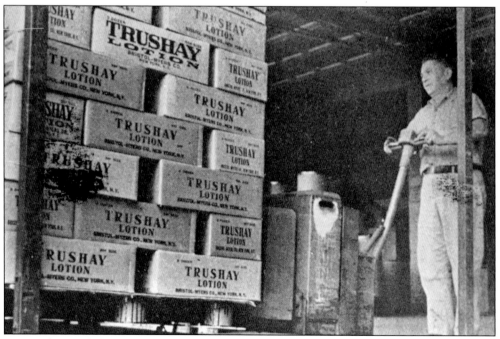

An employee of the Bristol-Myers Company tows boxes of Trushay, a hand lotion, to a loading platform for shipment *c*. 1950.

Herman Arlein awards a certificate from the Hillside Lodge, B'nai B'rith, to Morris Lubin of Hatfield Wire and Cable Company for the company's and Lubin's service to the township c. 1950. The lodge was the second largest in New Jersey. It now is part of the Springfield lodge.

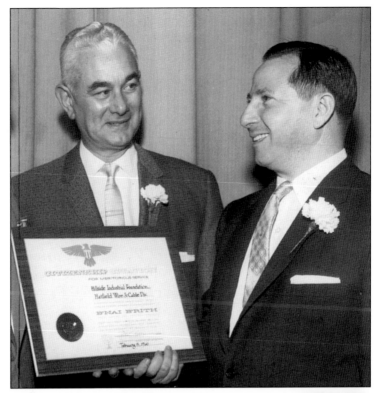

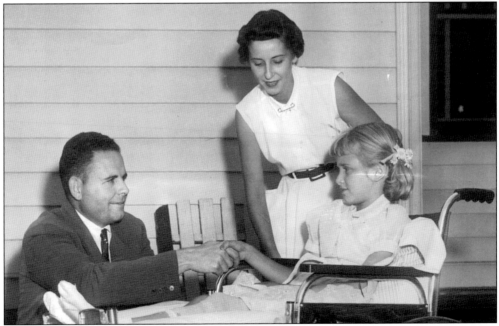

William Bristol III, whose company, Bristol-Myers, gave a wheelchair to the Hillside Ambulance Squad to loan to persons who need it, talks with Kathy Giordano. Kathy Jacobus, a squad member, watches. The company also put up veterans housing on Hillside Avenue for its returning veterans, and the township built 12 houses on Wolf Place.

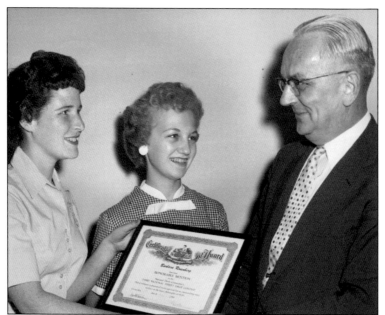

James A. Oneil, president of the Hillside National Bank, hands a certificate to Barbara Rosenberg, left, for her entry in an essay contest, while Nancy Cox waits to receive her first-place award. The essay contest and an art poster contest, asking contestants to describe or show ways to be more thrifty, were conducted for 10 years.

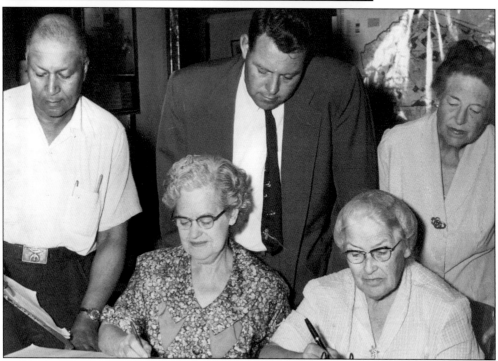

The staff of Daniel Leeds Miller Inc., a coal company, met in 1957 for some last minute details before the merger with Kingston Company in Union. Pictured, from left to right, are follows: James Allen, the oldest driver; Anna Gill, secretary and assistant treasurer; D. L. Miller III, vice president and manager; Elizabeth McConnell, cashier; and Mary Miller, president. The company was the first major business to move into the area in 1897. Both D.L. Miller and his son D.L. Miller II were active in the formation of Hillside in 1912. D.L. Miller donated land for the Hillside National Bank on North Broad Street at Ridgway Avenue.

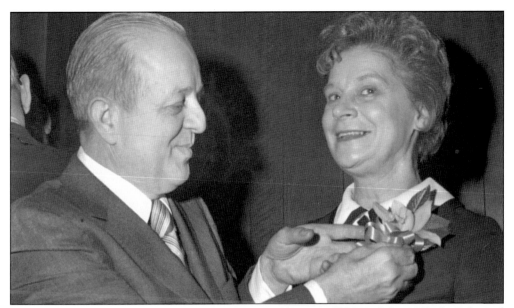

John Halkovich pins a corsage on his wife's shoulder at a dinner of the Hillside Industrial Association. He was associated with the Bristol-Myers Company.

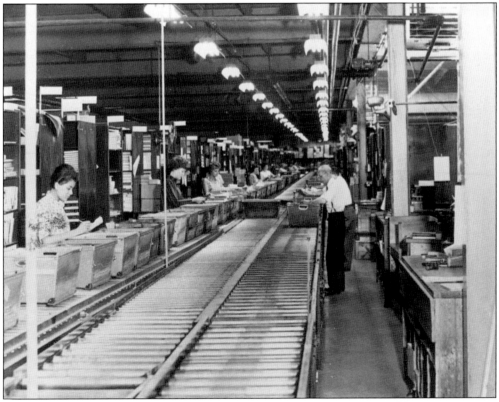

Employees box books at Baker and Taylor Company book distributors c. 1950.

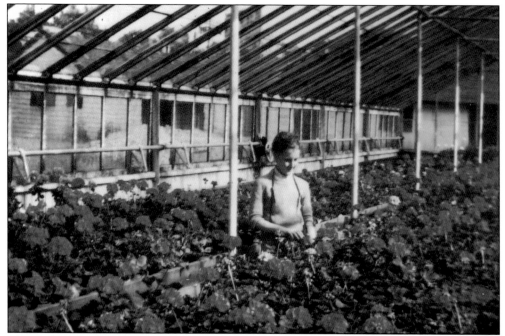

Margaret Ann Phillips inspects flowers in the Jacobi greenhouse in the early 1960s. The business was started in the 1850s by John Hutchinson, who died in 1870. His son, John T. Hutchinson followed him. When he died his widow operated the business until 1917, when she sold it to the Jacobi family. The Jacobis operated it until the early 1990s. A restaurant now occupies the site.

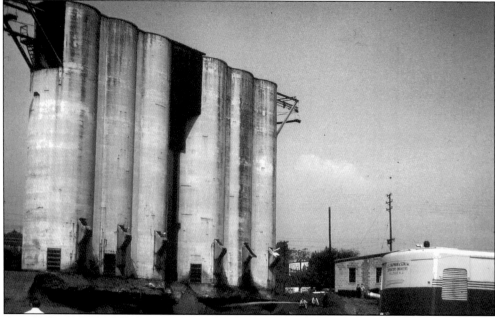

One of the most famous landmarks in Hillside for many years were the D.L. Miller coal silos that stood in the present Evans Terminal area. They were removed to provide more room for buildings and parking.

The Hillside Industrial Association was formed to improve relations between Hillside and its industries and to improve services to industry. Two Bristol-Myers employees, public relations representative James MacWhithey and community relations representative Harlow H. Curtis Jr., discuss plans and problems with industrial association member Frank McBride *c.* 1950.

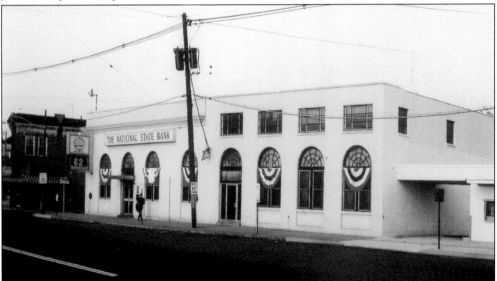

A small red brick bank building was erected on the corner of North Broad Street and Ridgway Avenue after D.L. Miller donated the land. In the 1950s, the bank building expanded from a one-story structure, with only two windows in front, to the building pictured here. The bank became the Hillside office of the National State Bank in Elizabeth in 1962. It now is a liquor store.

Harry A. Cooper, founder of the Cooper Alloy Corporation in 1941, manufacturers of stainless steel castings, spearheaded the founding of the Hillside Industrial Association in 1948 and the Hillside Industrial Foundation in 1952. The association sought to cooperate with the township and to seek improvements, such as an industrial post office. The foundation provided money for special projects, such as the Hillside Police Athletic League building and the Hillside Ambulance Squad. Both organizations have disbanded. The foundation's proceeds have been donated to the Hillside High School graduate fund.

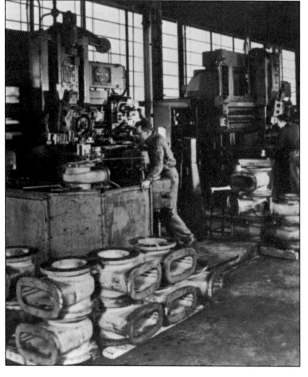

An employee of the valve and fitting division of the Cooper Alloy Corporation uses lathes to make stainless steel castings for a customer. In 1968, the state of New Jersey required three acres of the company's land for construction of Route 78. Operations in Hillside, except for the Vanton Pump Equipment Corporation, ended in 1978.

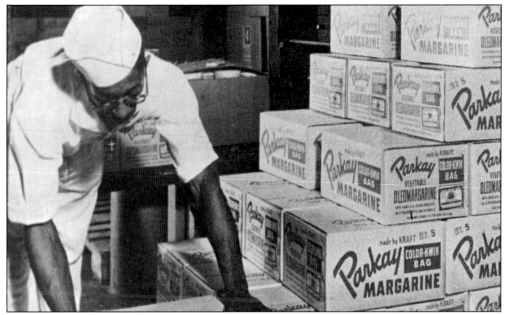

An employee of the Kraft Cheese Company in Evans Terminal stacks Parkay margarine. The building now is occupied by the Community Food Bank, which collects food for soup kitchens, shelters, and special programs for the poor.

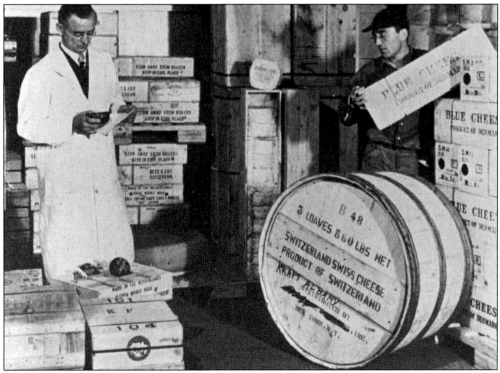

An employee of the Kraft Cheese Company checks the inventory in Swiss cheese, which is in the large barrels.

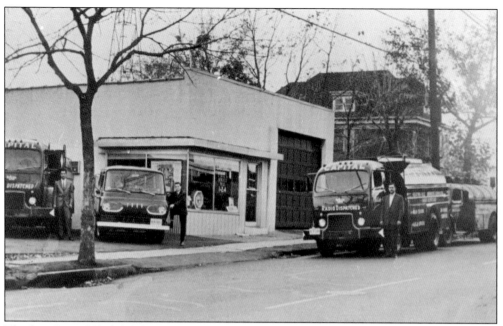

The first Capital Fuel Oil Operation was attached to the residence at 354 Hillside Avenue. The father and sons lined up with their trucks for this photograph, taken in front of the office and garage addition placed in front of the house. They are, from left to right, Louis, Patrick, and Pasquale J. "Patsy," the father. The third son, Gregory, was to the left of the photograph. He is operating the company in Cranford today.

Robert Jones was appointed economic adviser in Hillside to promote the township for industry after the 3 percent sales tax became effective. Unfortunately, he died in a drowning accident.

Joshua Lionel Cowen invented the Lionel Lines toy trains, which he originally sold door-to-door. He began mass-producing them when they became popular. In 1929, he built a huge factory on the Irvington-Hillside line and employed more than 4,000 people during peak seasons. The factory was sold to General Mills Inc.

Henry Groh presents Juanita G. "Miss B" Balderston a bouquet of flowers in 1960. It was her 40th anniversary of employment at Hillside National Bank, as well as the bank's 40th anniversary. In 1921, she rode on the wagon on top of the money when the bank moved from the real estate office of George Compton to its new building. Until 1937, she was the bank's only woman employee. In earlier times a number of bankers considered women unable to do the work.

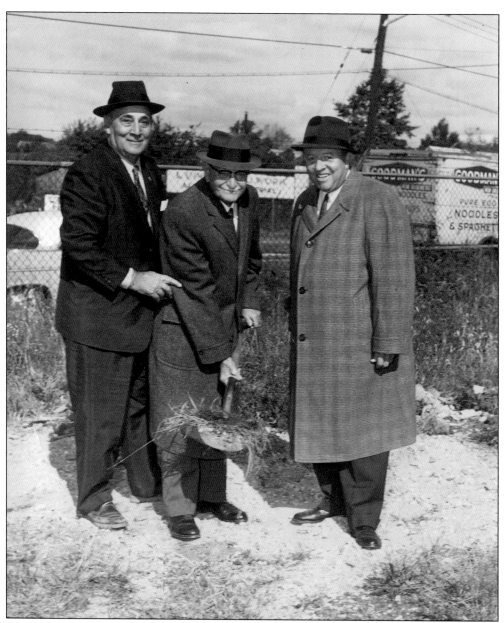

David Doremus, one of the founders of the Hillside National Bank, wields the shovel in the symbolic groundbreaking for a new office on Liberty Avenue in 1962. Before the building was completed, the bank had merged with the National State Bank in Elizabeth. Watching Doremus are David O. Evans, left, building contractor, and Harvey W. Peace, bank vice president. Evans built the factories on Montgomery Street, the Chapman-Montgomery tract on Central Avenue, Evans Terminal, and automobile row on North Broad Street.

Five

WE ORGANIZE

Representatives of three service clubs in Hillside discuss a planned program for the township. They include, from left to right, Arnold H. McClow of the Hillside Lions Club, Franklin Feltman of the Hillside Kiwanis Club, and Albert Swider of the Hillside Rotary Club.

Among the guests at a Roaring Twenties party of the Ladies Auxiliary of the Italian-American Association in 1977 are, from left to right, Vito Voltero, Joan Menza, and Alfred Lordi, a school board member from 1967 to 1973.

In August 1974, members of the Hillside Lions Club gave a donation for a shelf of books in memory of Samuel Leventer to the Hillside Public Library. Participating in the ceremony are Anna Mae Gibas, August Paolercio, Kenneth Geiger, Mrs. Samuel Leventer, Abe Haber (president of the Library Board of Trustees), Beatrice Zisman, and Carol Menza. The women are members of the Friends of the Hillside Public Library.

Harold Benzing, left, a member of
the Hillside Industrial Association,
literally sings for his supper at one of the
association's functions, as the emcee holds
the microphone.

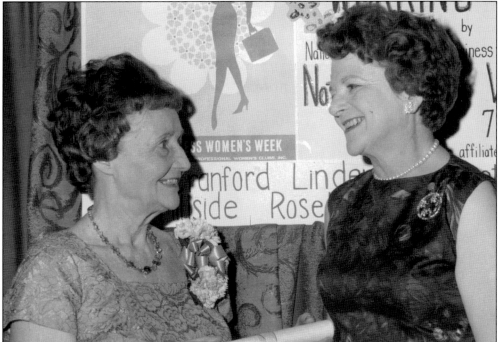

Elizabeth McCraith, left—known as "Cappy" because of her earlier work with the Girl Scouts,
director of recreation, and the prewar Shanty Shack Canteen—was the first Business and
Professional Women's Club Woman of Achievement, in 1965. Irene Phillips, president,
presents her with a citation during the club's observance of Businesswomen's Week.

Participating in the Valentine's Ball of 1976 at the Church of Christ the King are, from left to right, Rose Intrabartolo, Mrs. John Macaluso, and Mrs. Frank Barlo.

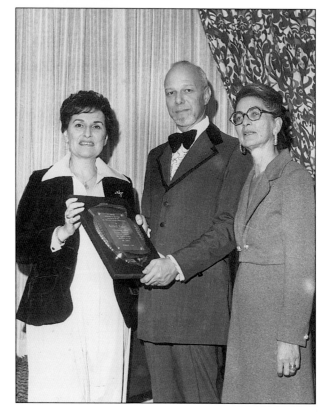

Mrs. Harold Brewster, left, president of the Eastern Union County Young Men-Young Women's Hebrew Association in Union Township, presents a Y Award to Herbert Cooper, who is accompanied by his wife. All three are Hillside residents. The presentation was made at the Harry Lebau Jewish Center in 1976.

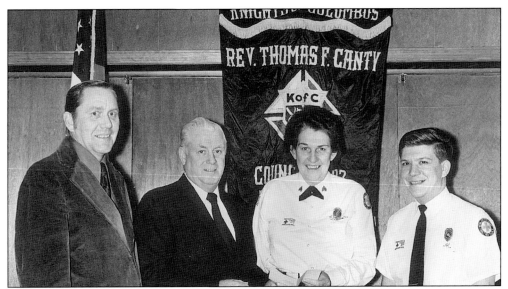

The Reverend Thomas F. Canty Council, Knights of Columbus, turned an old garage into a meeting hall. The council also has been generous in making donations for township projects. Val Kennedy, left, council president, and John Conlon made a donation on behalf of the Knights of Columbus to Eleanor L. O'Neil, ambulance squad president. With them is squad member, Alan Zimmerman.

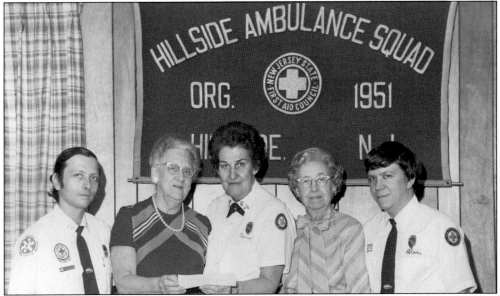

The Women's Club of Hillside, organized in May 1920, presents a donation to the Hillside Ambulance Squad. Mrs. Williard W. Cupit, president, second from left, and Mrs. Thomas A. Dwyer, second from right, made the presentation. Squad members receiving the contribution included, from left to right, Norman Sapolnick, Eleanor L. O'Neil, president, and Alan Zimmerman. The club organized the library and contributed to many local and statewide projects. It sponsored a Junior Woman's Club and an Evening Membership, the Fortnightly group. All belonged to the State Federation of Women's Clubs. The club ceased operations in 1992.

Mayor J. Arnold Witte signs a proclamation proclaiming National Business Women's Week in 1974, as Marie Oakie, president of the Hillside Business and Professional Women's Club watches.

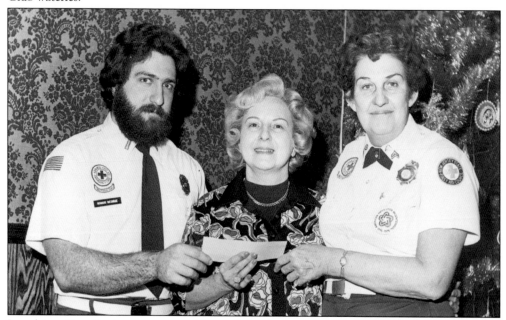

Josephine Castellucio, center, president of the Ladies' Auxiliary of the Italian American Civic Association, presents a $500 check for the purchase of radio equipment to the Hillside Ambulance Squad. With her are Howard Wesniak and Eleanor L. O'Neil.

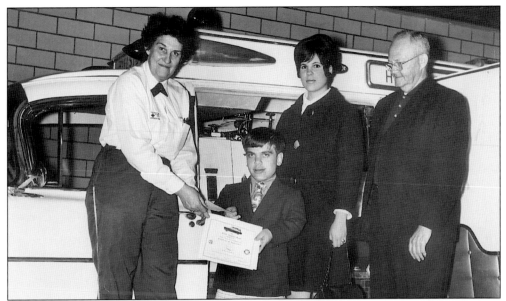

Larry Levee, president of Hillside High School's Class of 1972, spearheaded a teen dance at the U.S. War Veterans Memorial Building in 1970 for the benefit of the Hillside Ambulance Squad. He gives the $166 in proceeds to Eleanor O'Neil, left, as Latin teacher and class adviser Miss Gruszkowski and Thomas G. Greene Jr. watch.

Installed as officers of the Ladies' Auxiliary of the Reverend Thomas F. Canty Council, Knights of Columbus, for 1973–1974 were, from left to right, (seated) Mrs. James Silva, financial secretary; Patsy Cavalchire, treasurer; Mrs. Richard Madden, president; Mrs. Wesley Heidrich, vice president; and Mrs. Alfred Fogerty, recording secretary. Standing are trustees Mrs. Dominick Piro, Mrs. Charles Sabba, and Mrs. Frank Dunay.

Henry Groh admires a watch presented to him by the Italian-American Civic Association for his service to Hillside. With him, from left to right, are an unidentified man, Carmen Ferrigno, and Michael Tobia.

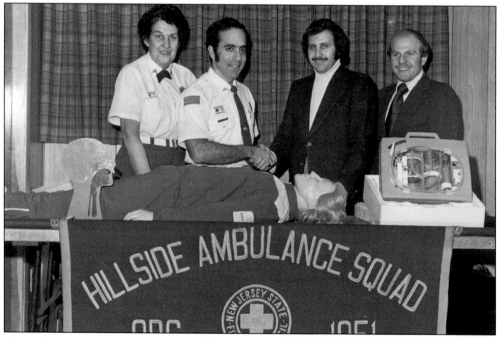

The Hillside Chapter of the Junior Chamber of Commerce (Jaycees) selected as its project in 1973 the Do Something Walk. Proceeds from the walk were given to the Hillside Ambulance Squad by Martin Prince, chairperson, second from right, and David C. Goldberg, president, right. Receiving the donation for the squad are Eleanor L. O'Neil and Bruce Plisner, squad president.

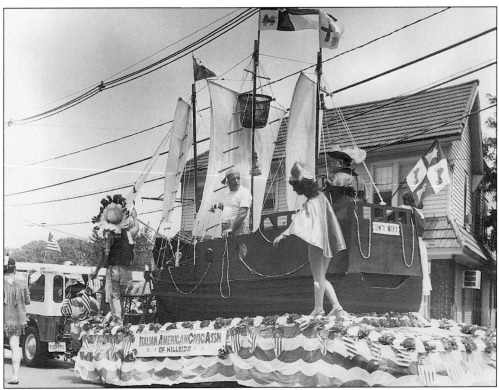

A model of the *Santa Maria*, one of Christopher Columbus's ships, sailed on the Italian-American Association's float for a Memorial Day parade. The association began in 1952 and transformed a building on Hillside Avenue at North Broad Street, once the welfare office, into a clubhouse *c.* 1968.

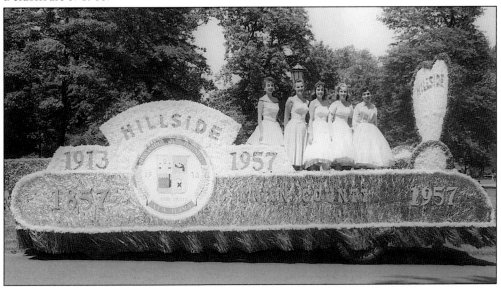

The Township of Hillside entered this float in a parade to celebrate the 100th anniversary of Union County in 1957. The communities once a part of Elizabethtown separated from the rest of Essex County in 1857. The date 1913 marks the year Hillside was formed.

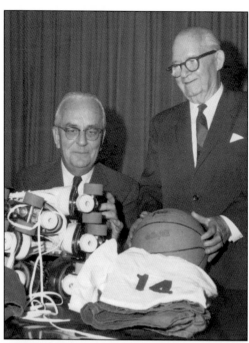

James A. Oneil, left, president of the Hillside National Bank from 1937 to 1962, and William Buie of Buie Steel Company inspect athletic equipment they have purchased for the Hillside Police Athletic League.

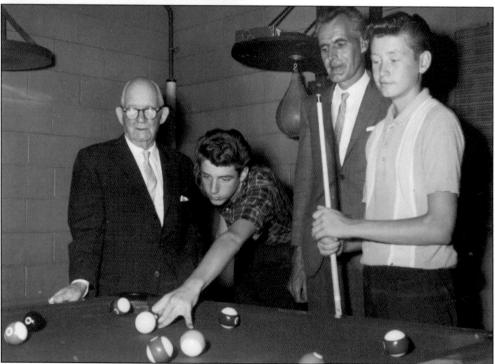

William Buie, left, and Alois Stier, second from right, watch two Hillside Police Athletic League members play pool in the police athletic building. Stier, a detective, was the director of the athletic league from 1958 to 1970, when the building was taken over by the township recreation board as a community center. The building, dedicated on September 17, 1960, was named for Buie because he was its major fund-raiser.

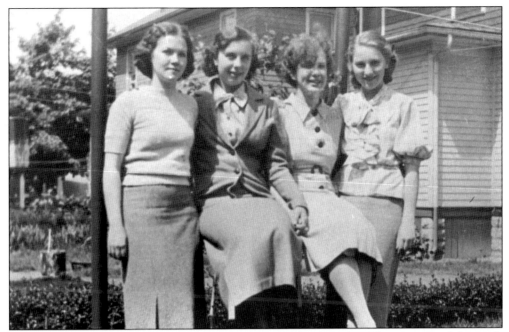

Hillside has many unorganized groups that meet for the fun of it. This quartet of four girls enjoyed lunch once a month during the 1935–1936 school year. They are, from left to right, Ruth Peterson, Shirley Fuller, Jean-Rae Turner, and Alice Hirman. The lunches stopped because Ruth went away to college. Shirley and Jean-Rae became teachers in the Hillside schools.

More than 60 years ago, a mother invited several little girls to her home for an afternoon. It became an informal club of classmates that still meets regularly. The classmates are, from left to right, as follows: (front row) Florence Morris Steinberger, Bette Hammer London, Lois Lessner Reiss, and Naomi Levin Cohen; (back row) Janis Weinberg Shafman, Janet Ribnik Tiheburger, Marion Schnel Alvan, Minna Kaphan, Sally Gooen Wovsaniker, and Carol Raphael Stromeyer.

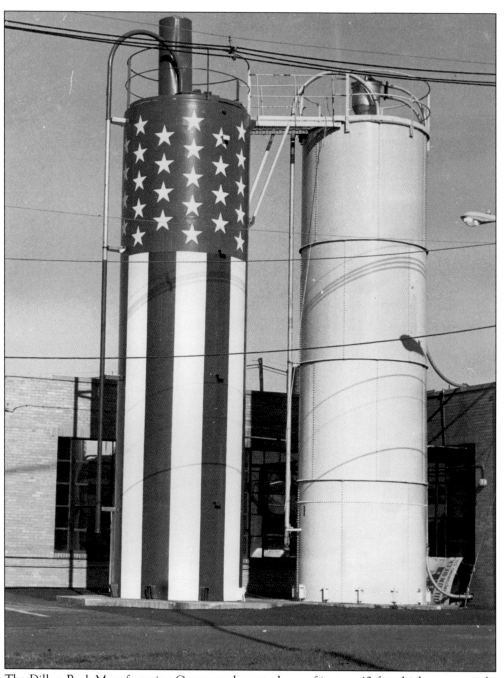

The Dillon-Beck Manufacturing Company decorated one of its two 40-foot-high storage tanks with the nation's stars and stripes in 1976. The storage tank contains about 78,000 pounds of plastic pellets.

Six

PEOPLE MAKE A COMMUNITY

Two children in the Weimer family ride in a tiny automobile at the family gasoline station at the corner of Long and Liberty Avenues in the 1940s.

Barbara Warren Girion, a teacher at Hillside Avenue School, now Walter O. Krumbiegel School, started writing for children when she was a teacher. After her children were grown, she began to write children's and young adult books.

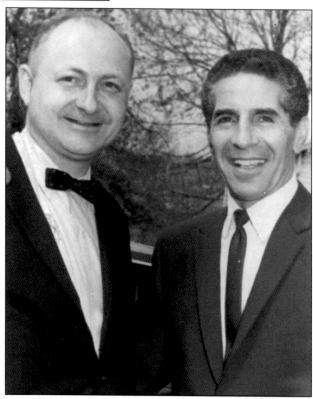

Richard T. Koles, left, joins Philip Rizzuto at a local function.

Vera Studney was known as the "doll lady" of Hillside because she made dolls for poor children. She used to explain that during the Depression her family lacked the funds to buy a 10¢ doll for her. She wanted all little girls to enjoy having a doll.

Ann Romeo Lord, who was active in making ceramics, became Hillside's first woman mayor in 1994. She was a member of the committee for nine years. She now works for Union County

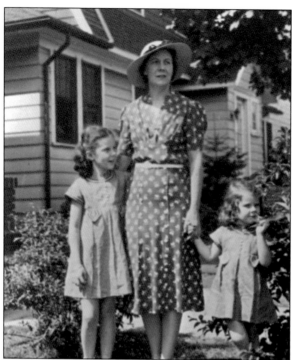

Mrs. Harrison D. Simpson and her two daughters are all dressed up for an outing *c.* 1938. Nancy is on the left, and Letitia is on the right.

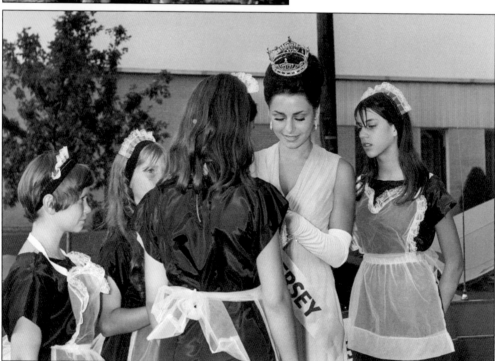

Hela Yungst, who became Hella Young, signs autographs after she wins the title Miss New Jersey in 1970. A native of Tel Aviv, Israel, she also won the titles Miss Newark State College and Miss Union County, and she was selected as one of the Outstanding Young Women in America in 1971. She is associated with the New Jersey Lottery Commission.

Gertrude Singe has a little auto to ride in, but she has to pedal it herself. The photograph dates from *c*. 1920.

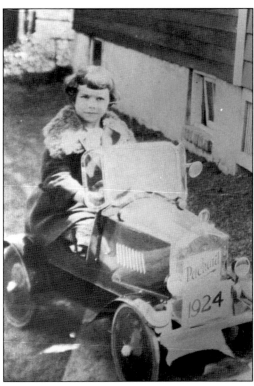

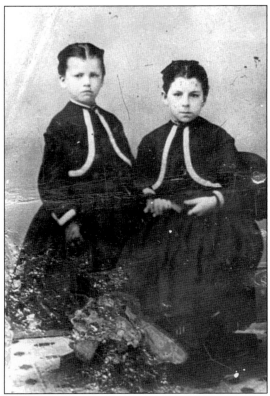

Anna Bragger and Addie Rose Anderson of Elizabeth are dressed alike for this portrait. Their hair has been arranged in the style that their mothers wore. Their dresses are trimmed with braid or ribbon.

John M. Brown, left, a U.S. Marine during World War II, was the first veteran tapped for political office in Hillside on his return. The high school teacher was elected in 1947 and served on the township committee from 1948 to 1950 and as president of the Hillside Board of Health, which was composed of the committee members. William Gural, right, an U.S. Navy veteran and a young lawyer, was selected as a candidate in 1952 and served on the township committee from 1953 to 1958, including a term as mayor in 1956. He became a deputy attorney general until he was named the director of the rate counsel for the New Jersey Public Utilities Commission. He now serves as a judge in rate disputes.

William Ivans, left, is welcomed home from the service at a party given by his parents, Gertrude and George Ivans.

Edward Smith was always proud
to be a U.S. Marine. He posed for
this photograph before reporting
to the Asian Pacific Theater.

Alan Zimmerman was a peacekeeper in
Germany in the 1950s. He learned how to
operate one of the first computers.

Arnold H. McClow, who spent his life writing press releases or working for newspapers, was given a telephone and typewriter just like home when he went into the U.S. Army.

Henry Tyranski, Jean Bentley, Alice Spitzberger, and Herbert Anderson pose for a photograph in front of the new housing area on Westminster Avenue. The house behind them became the home of Phil Rizzuto, the New York Yankees shortstop.

Marvin C. Smolenski served with the
U.S. Navy in a construction battalion.

Marvin C. Smolenski's son, Felix, joined
the U.S. Army and became a career army
man, retiring as a colonel.

Madeleine Massey went to school to become a model.

Madeleine Massey married Elroy Mess, whom she had met in high school. She was a Girl Scout leader when her daughters were old enough, and she eventually went to work at the Washington Rock Girl Scout Council in Westfield. She conducted several bicycle trips for the girls, including ones to Holland and Nova Scotia.

Alice Spitzberger is dressed for a program c. 1927.

Gertrude Singe is a flower girl in this photograph taken c. 1919.

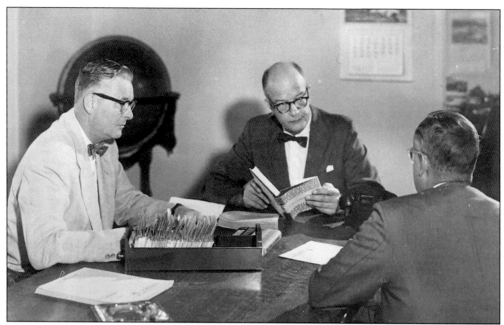

Author Nat Bodian, center, confers with two booksellers while doing public relations for Baker and Taylor. He has written 11 books and has been a newspaper reporter and a public relations representative. One of his books traces the lineage of U.S. presidents and finds that Marilyn Monroe was related to the Bush family.

Peter Runfolo, president of the Make-A-Wish Foundation of New Jersey, devoted his time to giving a sick child his or her last wish. Many of the children asked to go to Disney World.

Seven

PUBLIC SAFETY

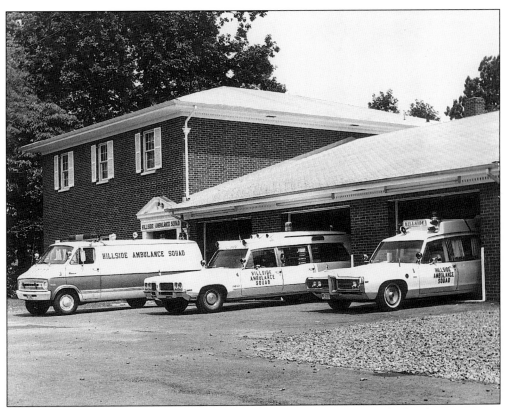

The new Hillside Ambulance Squad was formed in 1952. The squad's headquarters were opened in 1974.

Henry Goldhor, left, one of the founders of the Hillside Ambulance Squad, uses the new radio to communicate with squad members. Thomas G. Greene Jr. listens. Greene was one of the most active directors of the Shanty Shack, a teenage program just before World War II.

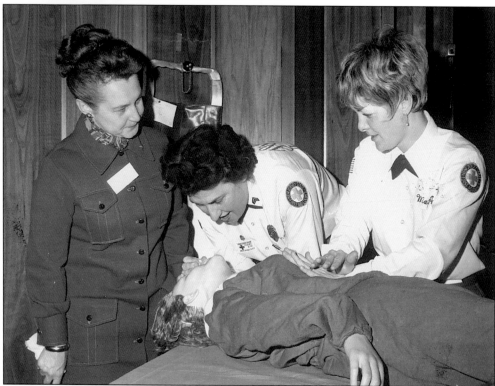

Eleanor L. O'Neil, center, demonstrates how to give mouth-to-mouth resuscitation on "Nellie," a model.

Edward Smith collected 250,000 trading stamps, which he gave to the Hillside Ambulance Squad for equipment. Eleanor L. O'Neil, president, accepts the stamps. At one time, some grocery stores, gasoline stations, and other places issued trading stamps to customers making a purchase. These stamps could be pasted into booklets which, when filled, could be exchanged with the stamp company for a wide variety of merchandise. One of the most widely known stamp companies was Sperry & Hutchinson, which put out S & H Green Stamps.

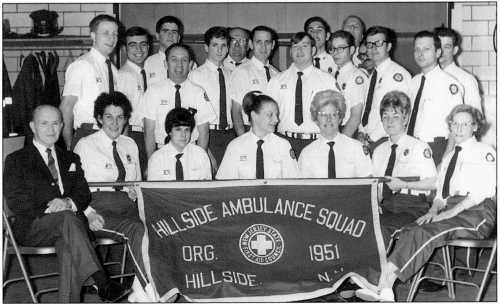

Officers of the Hillside Ambulance Squad pose for their official portrait in 1969. They include, from left to right, the following: (front row) Jess Hollander, a trustee; Eleanor L. O'Neil, president; Roberta Asch; Carol Burnett; Grace Cicchino, corresponding secretary; Mary Ann Aitken, recording secretary; Eleanor Kifner, historian; (back rows) Jack Heath; Thomas Domerski; Robert Mason; Samuel Cohen; Wayne Hess; Henry Edighoffer; Benjamin Feldheim; Ira Weiss; Stuart Finfter; Frank Williams; Joseph Szalay, treasurer; Morton Bluestone; Robert Verankamp; Norman Sapolnick, trustee; and Joseph Noble.

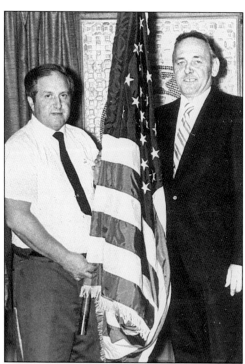

Richard Tillou, right, the exalted ruler of Hillside Elks Lodge 1491, presents an American flag to Albert Alboum, president of the Hillside Ambulance Squad, in 1971.

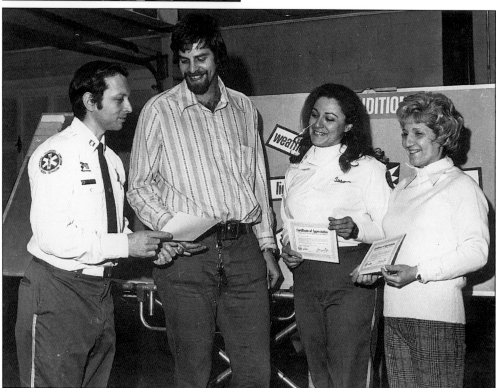

Members who have qualified as ambulance drivers receive certificates from Norman Sapolnick, left, captain. Elaine Smith is on the far right.

New members Mary Hollimar, left, and Sandy Meehamtake a first aid course taught by Thomas Greene Jr.

Sgts. Ira Weiss and Jerome Eben of Company B, 2nd Battalion, National Guard, both members of the Hillside Ambulance Squad, spent a month with the squad working two twelve-and-a-half-hour tours of duty. Eben checks the resuscitator, while Weiss restocks the first aid kit after they responded to seven emergency calls.

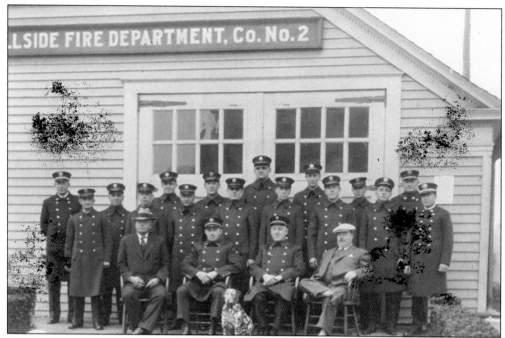

Fire Company No. 2 poses in front of the firehouse, a former real estate office, in 1930. After a regular firehouse was opened on Hillside Avenue in 1955, this building was used for the fire auxiliary for about 15 years. Then, the Firehouse Playhouse took it over for several years and, later, it reverted to the auxiliary.

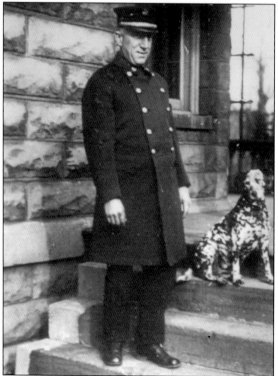

Fire Chief Albert Chamberlain pauses on the steps of the municipal building with his dog c. 1923. He served as chief from 1921, when the department was organized, to 1943. The Saybrook Volunteer Department began in 1913. A huge round gong at Long and Hollywood Avenues was used to call volunteers to a fire.

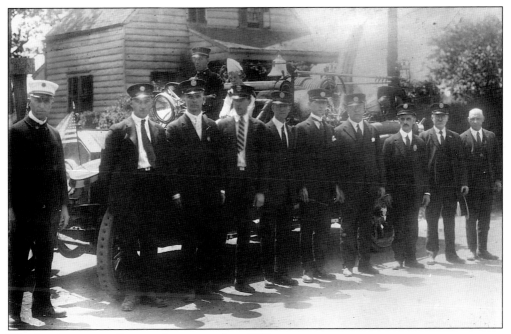

The fire department lines up for a portrait *c.* 1921.

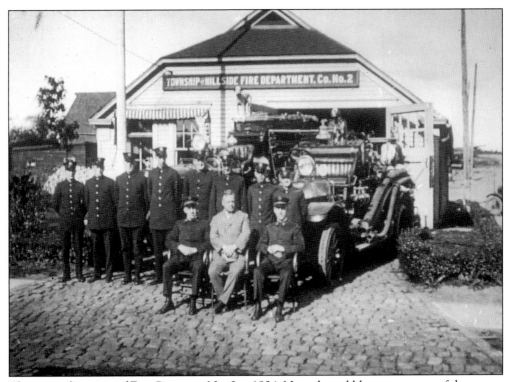

This is another view of Fire Company No. 2 *c.* 1924. Note the cobblestones; many of the streets had them because of the use of horses.

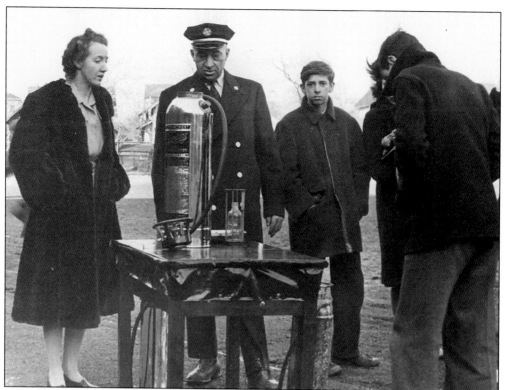

Fire Chief George P. Dorer demonstrates the use of a resuscitator at one of the schools. Dorer was chief from 1943 to 1950.

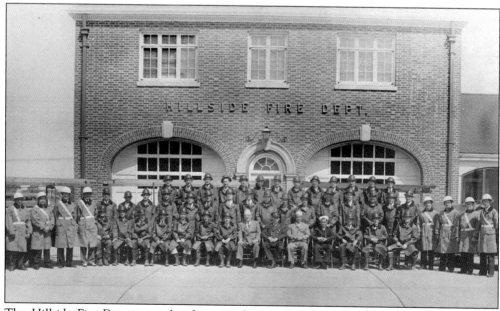

The Hillside Fire Department headquarters houses Fire Companies No. 1 and No. 3. The facility was built c. 1940. It has had an addition since. It stands on Hollywood Avenue opposite Leland Place.

Township committee member Anton A. Vit, left, presents a donation for the Firemen's Mutual Benefit Association to Fire Capt. Robert W. Sonntag.

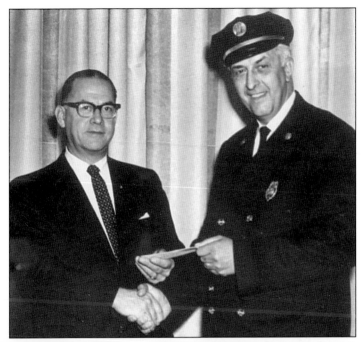

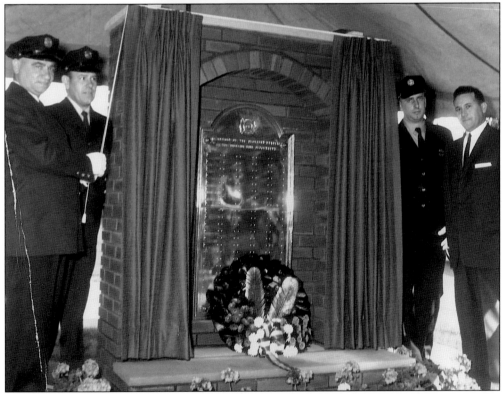

Charles Mancuso, fire commissioner, stands at the extreme right, as members of the fire department, unveil a memorial to Hillside firefighters who have died since the department was formed. None has died in a fire.

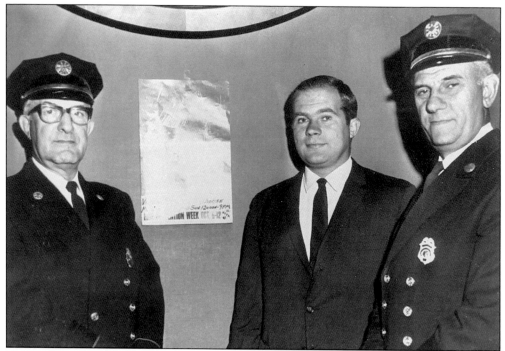

Deputy Fire Chief James Intrabartolo, Fire Commissioner J. Arnold Witte, and Fire Chief Carmen Dill prepare for Fire Prevention Week *c.* 1968.

Robert Diamond of the township committee is initiated as fire commissioner by Fire Capts. Andre J. Adamchak, James Foran, and Michael Marnsick *c.* 1963.

Eugene W. Andrukite, fire commissioner from 1972 to 1974, pins a badge on Fire Capt. Ludwig Lew of the Hillside Fire Department on his promotion to captain c. 1972, while Fire Chief Carmen F. Dill watches. Lew played with a minor league baseball team for a few years.

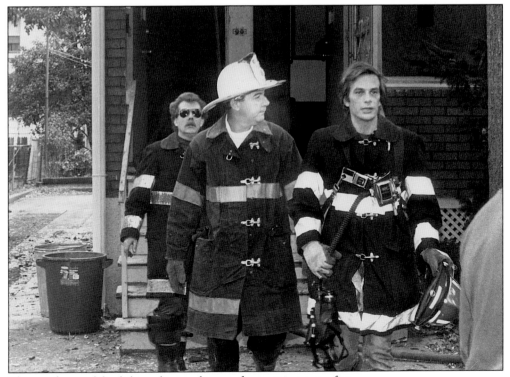

Three exhausted firefighters leave a house after putting out a fire.

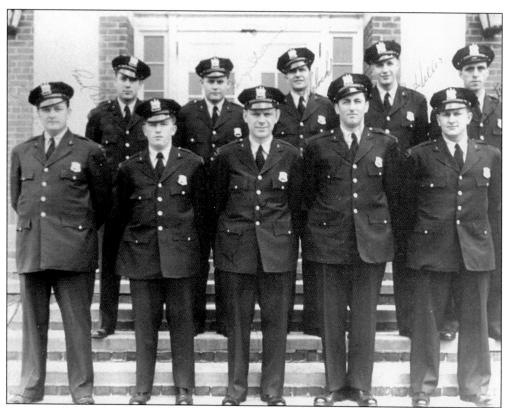

Ten men joined the police department when World War II ended. All were veterans.

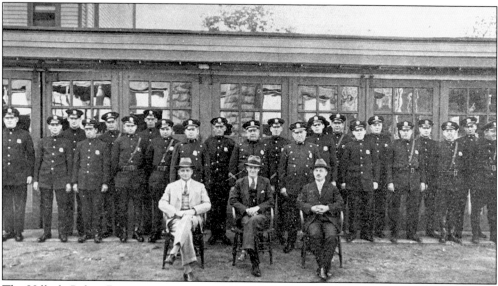

The Hillside Police Department was organized in 1918. The department had grown to this size by 1929, the year this photograph was taken. When the Crane property was acquired for the municipal building in 1923, the police department occupied the first floor. The living room became the courtroom; the dining room, the police desk; the kitchen, the jail; and the sun porch, the chief's office.

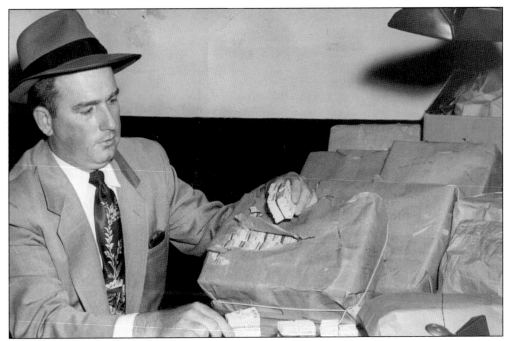

Police Det. Robert J. Mason counts the number of illegal lottery slips confiscated in a raid in 1955.

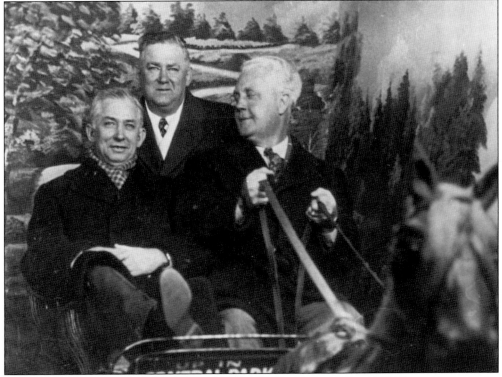

Police Chief Paul F. Korlesky takes a ride with his boyhood friend William Runyon, the postmaster in Elizabeth, c. 1960.

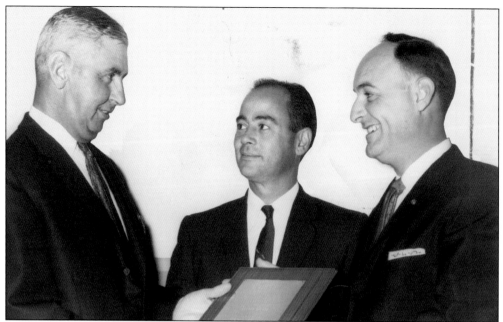

Deputy Police Chief Charles Grant, left, receives a plaque for "service above self" from Leonard Barlo, right, president of the Hillside Chapter, UNICO National in 1962. Looking on is V. William Di Buono, chairman of the awards committee. Magistrate Di Buono later became assignment judge of Union County.

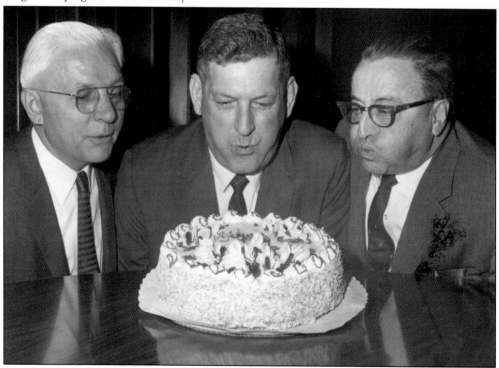

Deputy Police Chief Harry Schuetzle, court clerk Clarence Van Deursen, and Det. William Dierolf blow out a candle on a 50th anniversary cake in 1963.

The father and son team of Alois and Jeffrey Stier earned 23 decorations, including four awards for valor and a combat cross. Both now are retired. There are several sons of former officers on the department, including three Silvas, one Baum, one Sadlon, one Wempa, one King, one Hach, one Smith, and Jeff Lordi, whose father, Anthony, was killed as he guarded a fast food restaurant on North Broad Street. Jeff's brother Greg is with the Plainfield Police Department.

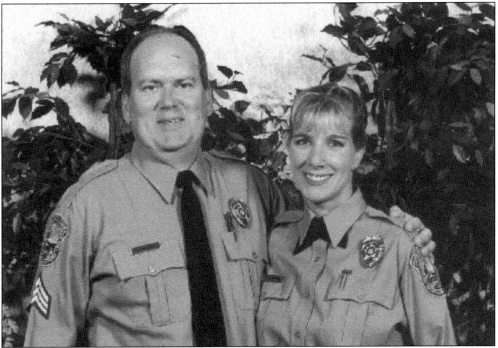

Alois Stier Jr. and his wife, Kathy Stier, are both members of the Dade County Police Department in Florida. He is a helicopter pilot; she serves as a radio operator. Another son of the Stiers, Arthur, is a retired parole officer in Essex County.

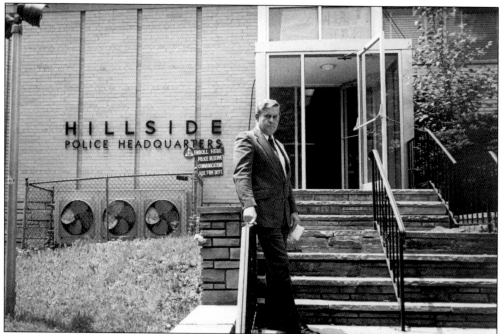

Police Chief George A. Shelbourne pauses for a moment before he enters Hillside Police Headquarters, in the municipal building He became chief in 1970, and he headed the Union County Police Academy in Cranford from 1971 to 1976.

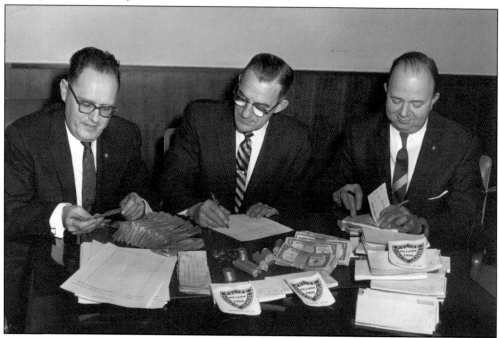

Counting money for the Police Athletic League building in 1959 are, from left to right, Henry Groh, a vice president of the Hillside National Bank; Louis A. Dischler, a member of the township committee, mayor in 1961, and township clerk from 1961 to 1975; and Det. Lawrence Lillie.

Members of the police auxiliary are awarded their badges. In front, from left to right, are Det. William Dierolf; unidentified; Arthur T. Lee, civil defense chairperson; and Thomas G. Greene, first aid instructor and schoolteacher. Civil defense activities were revived in 1950, after the outbreak of the Korean conflict.

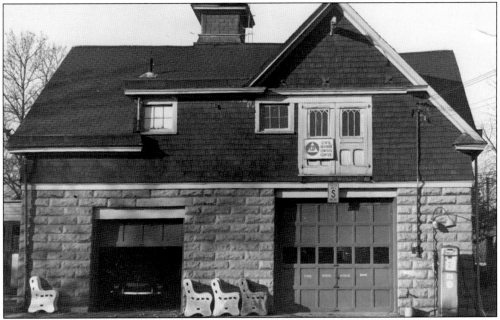

This barn once sheltered the prize horses of Raymond Crane. After the township leased the property, it served as fire headquarters until 1940. Then, it became the police vehicle garage. After the new police headquarters was opened with a new garage, it was used by the civil defense team. Next, it became the center for the Hillside Police Athletic League for four years until the William Buie Community Center was opened.

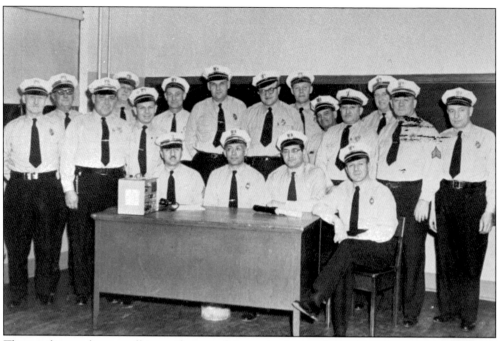

The auxiliary police are all in uniform ready to assist the regular police.

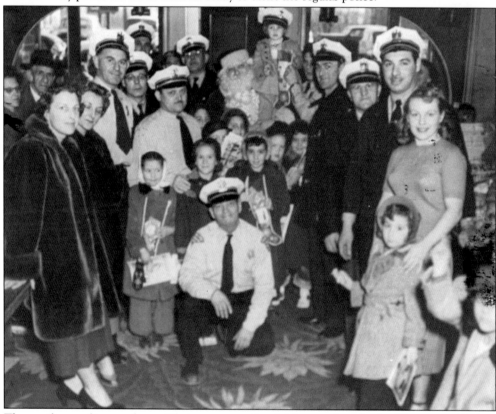

The auxiliary police conduct a Christmas party for children at the Mayfair Theater *c.* 1956.

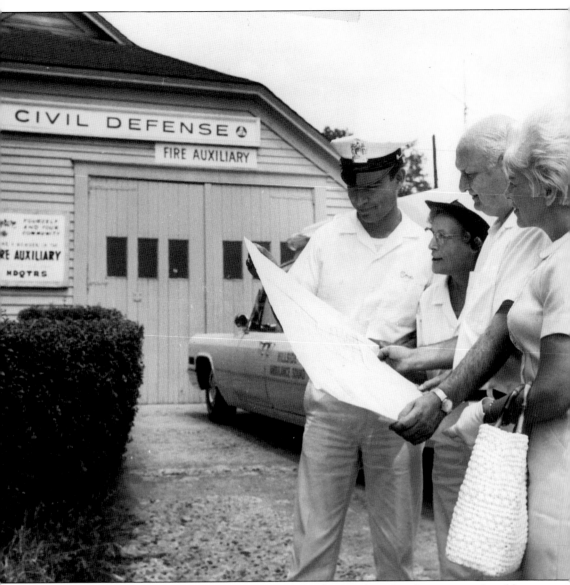

Members of the Hillside Ambulance Squad inspect the fire auxiliary headquarters in the old Fire Company No. 2-real estate building on Maple Avenue.

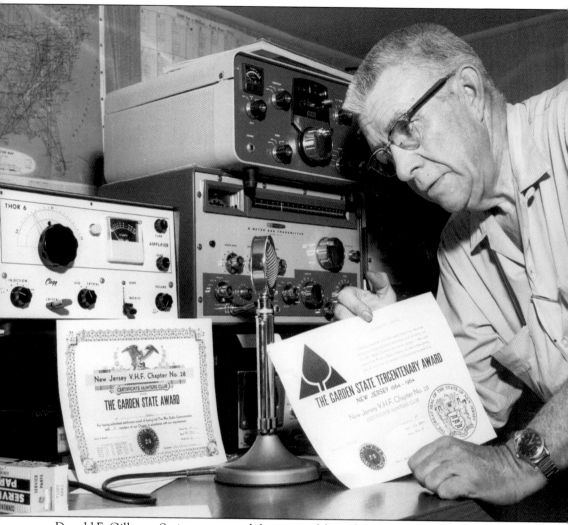

Donald E. Gillmore Sr. inspects awards he received from the New Jersey VHF, Chapter 28, and the Garden State Tercentenary Award in 1964 for his work as a Ham radio operator.

Eight

FAITH

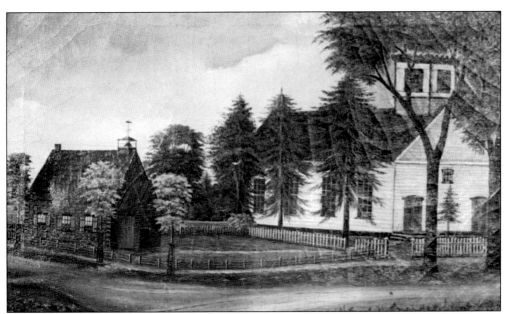

The Lyons Farms Presbyterian Church first met in 1849 in the Lyons Farms School. A small building was erected shortly afterward. It was replaced in 1902, when this section of Lyons Farms was annexed by the city of Newark. A brick addition was erected in 1922. The church became the Elizabeth Avenue-Weequahic Presbyterian Church of Newark when the Weequahic church was demolished to make way for Route 78. Artist S. Lyon did this painting c. the 1850s.

Thomas Fitzpatrick requested that the King Street Mission Church be named for his wife, Catherine, who died in 1910. When he died, he left his estate to St. Catherine's Church, and the present building was dedicated in 1928. Fitzpatrick Street is named for him.

The first church within the boundaries of today's Hillside was St. Catherine's Roman Catholic Church, which was started in the home of John Guyer, at 137 Conant Street, in May 1904, by St. Mary's of the Assumption Roman Catholic Church in Elizabeth. The diocese decided the new church should be located closer to the center of Elizabeth, and Immaculate Conception Roman Catholic Church on Union Avenue was built. A dwelling purchased by the diocese on King Street became a mission church.

A survey by some theological students led to the formation of Calvary Lutheran Church in 1922. A fund-raising drive was started and, by 1924, the present site on Maple Avenue at Clark Street was purchased and ground broken. The church was dedicated on October 4, 1925. An addition was added in the 1980s. Today, it is being used for a children's day-care center.

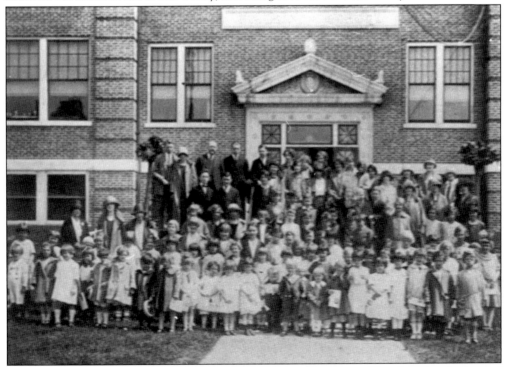

The congregation and Sunday school of the new Calvary Lutheran Church gather in front of Hillside Avenue School. The Church used the school for three years until the little church on Maple Avenue could be finished.

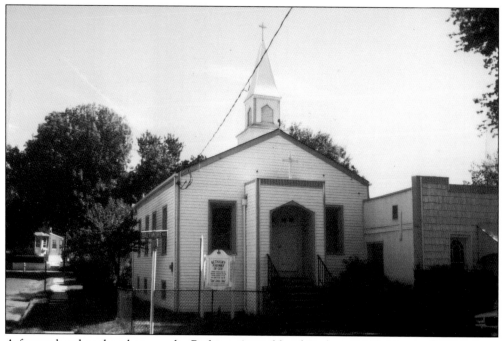

A former butcher shop became the Bethany Assembly of God, at 211 Baltimore Avenue.

Some members of the Bethany Pentecostal Church of Hillside gather outside their tiny church. Formed in the spring of 1938, the Church rented and then purchased the shop for services. The name was changed in 1955, when it became affiliated with the Assembly of God. A new sanctuary was completed in 1951, and a Sunday school addition was built in 1962. Early in its existence, the church held services in Polish; today, they are in English.

Rev. Thomas F. Canty was pastor of St. Catherine's Roman Catholic Church and founded Christ the King Roman Catholic Church as a mission church.

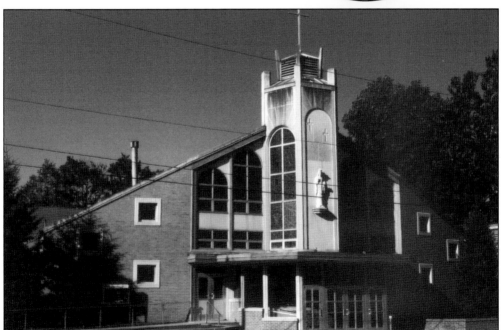

The mission church of St. Catherine's Roman Catholic Church was started in 1926 in the West Lyons Farms, Salem section. A small white clapboard chapel was constructed. The new parochial school on the site of the chapel, a modern church, a rectory, and a nunnery were opened in the early 1960s.

Jewish people moved into the West Newark and Lyons Farms sections in the early 20th century. Some of them conducted High Holy Day services in their homes because of lack of a synagogue. The Moses Hand House, on Maple Avenue, was purchased, and the first service was conducted on September 4, 1931. A front addition was added in 1937.

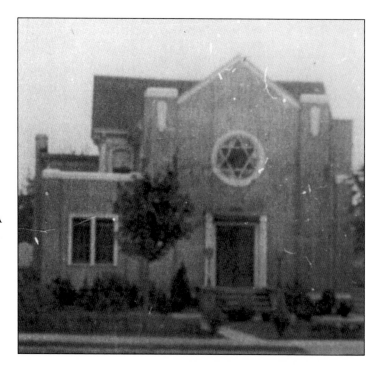

After World War II, the synagogue raised money to construct this sanctuary, which was dedicated on December 3, 1950. Torah Chaim Congregation of Newark joined the synagogue in August 1969, when its land was taken for Route 78. The name was changed to Sinai-Torah Chaim Congregation.

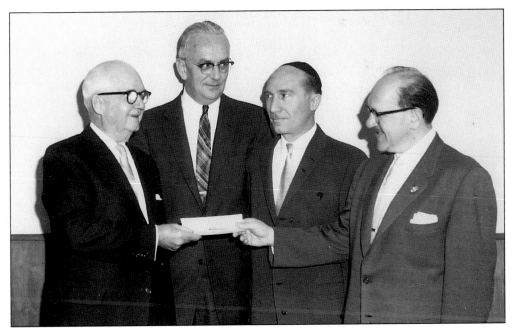

William Buie, left, of the Hillside Industrial Foundation presents a donation to Sinai Congregation, represented by Rabbi Eliezer Cohen, second from right, and Abraham Mankowitz, far right. James A. Oneil, president of the Hillside National Bank, watches.

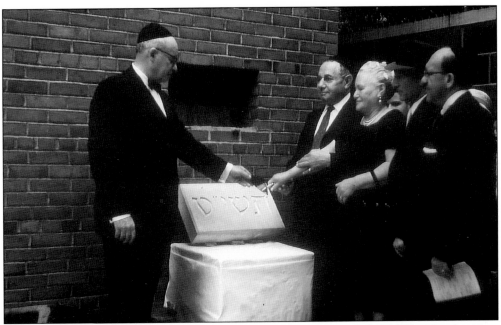

in June 1960, the cornerstone is laid for the new Sinai Congregation's $175,000 eight-classroom school, with auditorium and gymnasium. Participating, from left to right, are Max Kasoff, Mr. and Mrs. Isadore Holtz, and Abraham Mankowitz. By 1972–1973, the enrollment had decreased to eight children and the building was sold in 1973 to the Seventh-Day Adventists for a day school known as the Timothy Christian School.

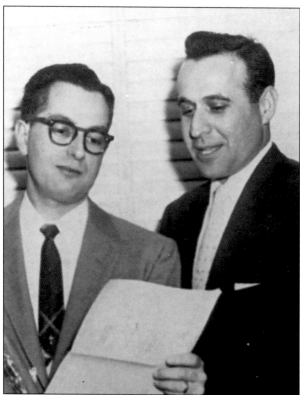

Dr. Joseph Peyser and Monroe Ackerman inspect papers for the purchase of the house owned by Mrs. Stockton B. Colt for the Conservative congregation, at 910 Salem Avenue.

The building was remodeled in 1960–1962 and renamed Shomrei Torah. After the breakup of the Soviet Union in 1991, many Russians moved into the area and the temple an became Orthodox one.

112

The Faith Assembly of God formed in the 1930s. The group built a new sanctuary on Yale Avenue in 1960. Originally, the congregation was mainly Italian. Today, it is African American.

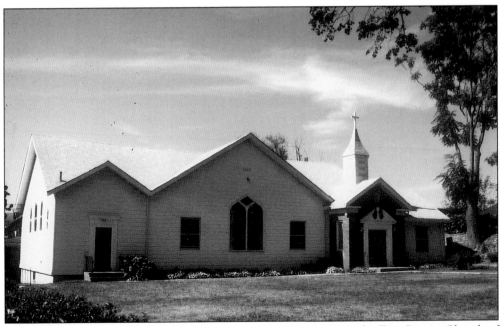

A Sunday school begun by Elizabeth Goeller in the 1920s became the First Baptist Church of Hillside in 1928. It replaced the Hillside Gospel Chapel, built in 1924. The Lyons Farms, later the Elizabeth Avenue Baptist Church, was responsible for the formation of both groups, as well as for the Lighthouse Gospel Mission on Long Avenue near Bloy Street. That building now is a private residence.

The first Protestant church begun in Hillside was a Sunday school at the home of Mr. and Mrs. Thomas J. Beale, on Conant Street, in 1908. It served the children in the new Saybrook section. When the classes outgrew the house, they were moved to the barn loft.

A small white chapel was constructed at Coe and Salem Avenues for the new Hillside Presbyterian Church in 1911. When the present building was constructed in 1927, the chapel was moved to the back of the property, where it continued to be used.

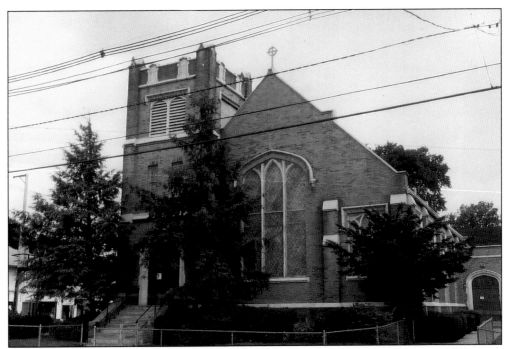

The Hillside Presbyterian Church has looked much like this since the day it was dedicated, in 1927.

St. John's Ukrainian Catholic Church of Newark organized the Immaculate Conception Ukrainian Catholic Church in 1946. In 1960, the construction began. The building is in the Byzantine style and has numerous colorful icons on the front of it. The church originally had a pastor; however, the congregation has moved and the church is now under the jurisdiction of St. John's.

Children in the beginner's department are dressed for the annual Halloween party at the Elizabeth Avenue Presbyterian Church.

Nine

SPORTS

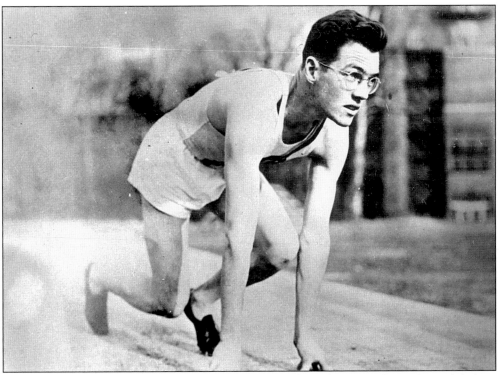

Hugh Short began his championship career as a seventh-grader in 1935 in a 50-yard dash in the Hillside Youth Meet. He won his first state championships in 1939, in both the indoor and outdoor 880-yards meets, and his first national championship in a 1,000-yard indoor race, setting a new record: 2.19.1. He was a member of the Georgetown University relay track team, which set a world record of 3.17.2 in 1942. Short was the winner and record holder for 24 years in Millrose Games in the 600-yard race with a time of 1.10.2, which tied the existing world's record. From 1976 to 1995, he ran in 27 marathons including 12 in Boston, where his fastest time was two hours 54 minutes and 15 seconds in 1979 at 57 years of age.

Sports are paramount in Hillside. In 1940, these youths, who enjoyed playing baseball and other sports, got together for this photograph. Most of them lived around Baltimore Avenue and called themselves the West Newark Boys. They are, from left to right, as follows: (front row) Fred Richie, Michael Humanik, Samuel Domina, Frank Spital, Frank DiLeo, Daniel Manzak, and Samuel Pawik; (back row) William Tomassio, Michael Powell, John Elsnick, Harry Powell, George Grigalovich, George Lazauskas, Harry Hyra, Anthony Fredo, and Joseph Schultz.

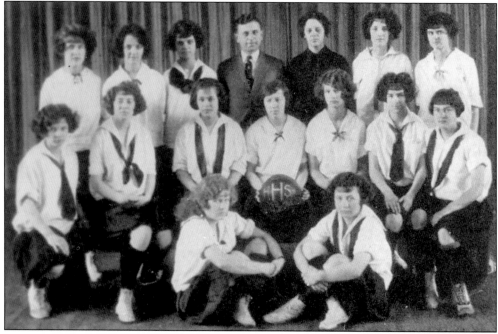

Fourteen girls in 1924 were on Hillside High School's basketball team. Pictured with them are Samuel Dubow, athletic director and advisory coach, and Irma B. Ostrom, next to him in a dark shirt, coach.

Walter "Babe" Warcizick, a member of Hillside
High School's Class of 1937,
was a four-star athlete for the school and
received letters in track, baseball, basketball,
and football.

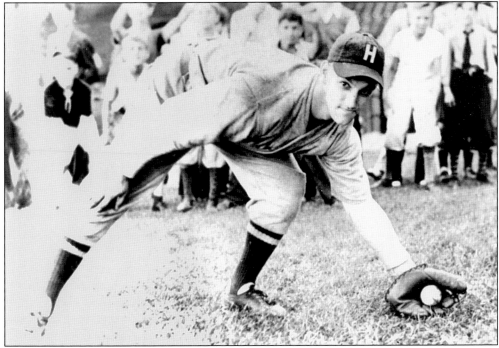

Walter Warcizick changed his name to Walter Warren after sportscasters and reporters had
trouble with his name and called him Warsick when he played for the Cincinnati Reds'
Durham farm team. Injuries put him on the sidelines. His scrapbook and other mementoes from
his athletic career are with the Rizzuto exhibit at the Woodruff House Museum Eaton Store.

David Halper, right, whose brother Lou Halper was one of the boxers at Laurel Garden in Newark, awards a trophy to Johnny Duva as the best boxer in 1975 in the boxing matches conducted by the Hillside Lodge 1514, B'nai B'rith, at the Hillside High School gymnasium. The lodge was the second largest in New Jersey. It has joined the Springfield lodge.

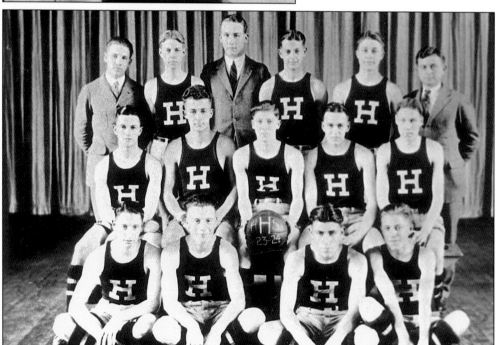

The 1923–1924 basketball team was the first organized boys' team in Hillside. Members are, from left to right, as follows: (front row) Clayton Barlow, Joseph Policastro, Leslie R. Tichenor Jr., and Robert Schnabel; (middle row,) George Kanthaky, Fred Krestner, Eddie Zusi, captain; Douglas Haviland, and William Squire; (back row) Eugene Hoffman, assistant manager; Allen Roberts; Fred Betz, manager; Elvin Ullrich; George White; and Samuel Dubow, coach.

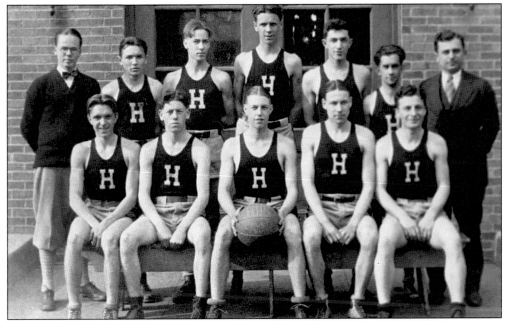

Members of the championship 1925–1926 basketball team are, from left to right, as follows: (front row) Edward Zilahy; Graham Winter; Allen Roberts, captain; William Squier; and Joseph Policastro; (back row) Robert Graff, manager; unknown; Jack Burt; Spencer William; Isadore Steinholtz; Richard Jagger; and Samuel Dubow, coach.

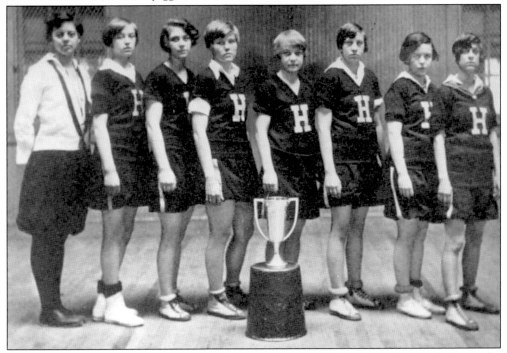

The 1929 girls track team at Hillside High School won a trophy. Irma O. Peer, left, was the coach. Team members were Annabell Herdiger, Marion Short, Ruth Butler, Helen Dankowsky, Helen Hansen, Ethel Taylor, and Joanna Karibanish.

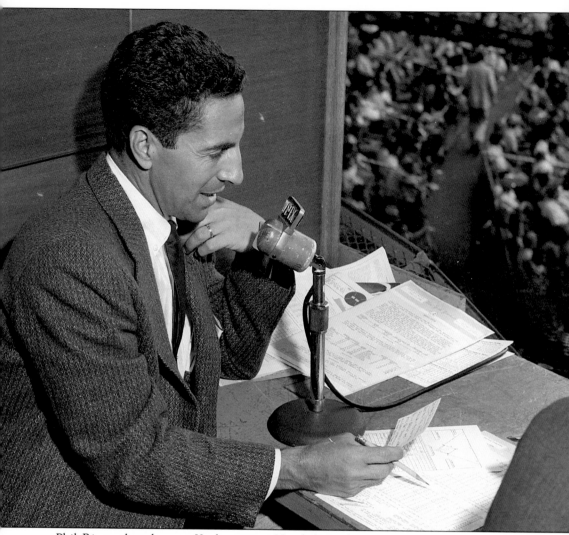

Phil Rizzuto broadcasts a Yankee game. His dialogue has been published in a poetry book because of his unusual rhythmic commentary. When he was elected to the Baseball Hall of Fame at Cooperstown, New York, several busloads of Hillside residents went to Cooperstown. A Rizzuto memorial room is part of the exhibit at the Woodruff House Museum Eaton Store.

Ten

THE PEOPLE'S GOVERNMENT

Richard S. Earl works with his horses at his farm on Conant Street. Earl served as a member of the township committee from 1916 to 1930 and was the township's mayor from 1918 to 1930. Under the committee form of government, the members select the chairperson, who holds the honorary title of mayor. Earl also was among the founders of the Hillside National Bank.

George Compton was township clerk of Union Township from 1909 to 1913, when Hillside Township was created. He then became township clerk of Hillside, serving until 1923. He was a member of the assembly from 1923 to 1930. He operated a real estate business, subdividing many farms on the hill into house lots.

Howard J. Bloy was township clerk from 1923 to 1961, longer than any other clerk in the township. He grew up in a farmhouse on Liberty Avenue near present-day Bloy Street. A veteran of World War I, he was a strong supporter of the veterans' groups that wanted to erect a U.S. Veterans' Memorial building.

Arnold H. Hebbe, left, was a township committee member from 1916 to 1919. Harry W. Doremus, right, a brother of David Doremus, served on the board of education from 1913 to 1939, including six terms as president, longer than any other person. Their uncle Abram P. Morris was a member of the board from 1913 to 1918, when he died. He served as president from 1916 to 1918. He also was township clerk of Union from 1902 to 1909. He is considered "the father of Hillside." The school on Coe Avenue is named for him.

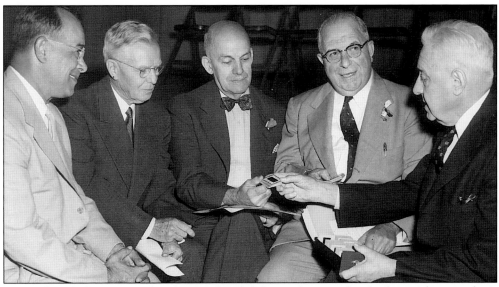

An unidentified man, at right, shows colored slides to the township leaders at the township's 40th anniversary in 1953. They are, from left to right, Raymond R. King, former mayor; Arthur G. Woodfield, superintendent of schools from 1913 to 1944; and George W. Herlich and Benjamin Hale, both former mayors. King's father, Charles King, was the unofficial mayor of Newark's Chinatown. Woodfield was superintendent of Union schools before the separation. Herlich served on the Union County Board of Chosen Freeholders and was the board's director for several years. Union County's juvenile detention facility is named for him.

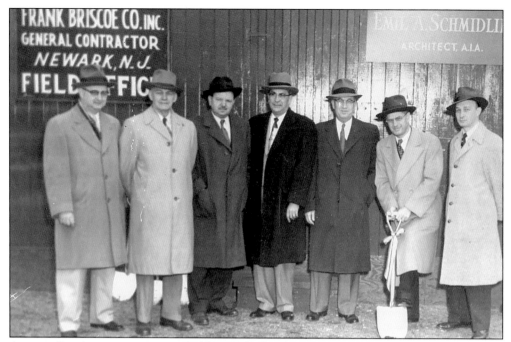

A groundbreaking ceremony was held in 1954 for the new municipal building on the Jagger property, at Hillside and Liberty Avenues. Participants are, from left to right, township committee member Henry Goldhor; freeholder George W. Herlich; architect Emil A. Schmidlin; township committee member Robert C. Kirkpatrick; township clerk Howard J. Bloy; and township committee members Milton B. Conford and John Malone.

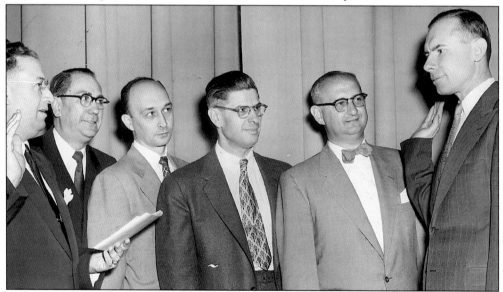

When William Gural, right, became a township committee member on January 1, 1953, the committee was composed of all Democrats for the first time in its history. Township clerk Howard J. Bloy, left, administers the oath of office. Others in the photograph are committee members Robert C. Kirkpatrick, John Malone, Milton B. Conford, and Henry Goldhor. Conford became mayor.

126

David Morrison, vice-president of the Hillside National Bank, and Edna Runfulo, vice-president of the Friends of the Hillside Public Library, look at some of the books donated to the library by the Friends group.

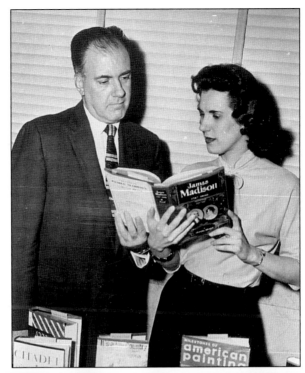

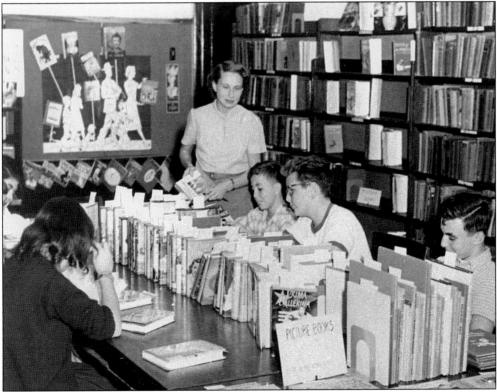

Lottie Smolenski, library director, watches children read in the library.

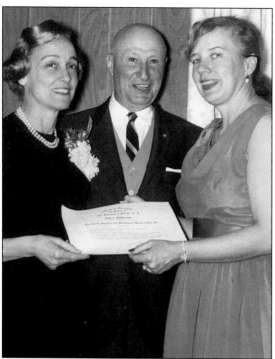

Adele Braelow, left, the first and only woman to serve as township attorney, was honored by the Hillside Business and Professional Women at a program held on the township's 50th anniversary to honor the first women to hold various township offices. With her are her husband, Col. I. Harry Luftman, and Jean-Rae Turner, program chairperson.

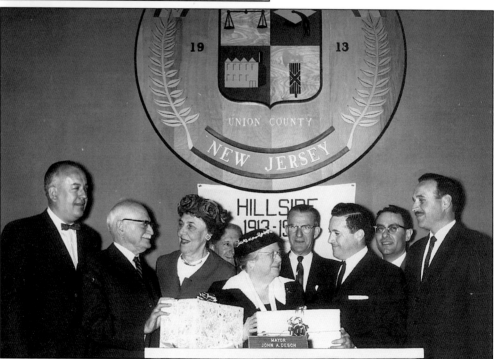

Celebrating the township's 50th anniversary are, from left to right, Mayor John A. Desch; David Doremus and Grace Tunison Acken, who had both lived in Hillside for more than 50 years; John Pozar; Celia Trousdell, another honoree; township clerk Louis A. Dischler; and township committeemen Charles S. Mancuso, Robert Diamond, and Monroe Ackerman.